Pattern + Palette²
SOURCEBOOK

ROCKPORT

First published in the United States of America by
Rockport Publishers, a member of
Quayside Publishing Group
33 Commercial Street
Gloucester, Massachusetts 01930-5089
Telephone: (978) 282-9590
Fax: (978) 283-2742
www.rockpub.com

ISBN-13: 978-1-59253-317-6
ISBN-10: 1-59253-317-5

10 9 8 7 6 5 4 3 2 1

Series Design: Anvil Graphic Design, Inc.
Design: Heidi Arrizabalaga
Layout and Production: Karen DeMattio and Sylvia McArdle
Chapter Opener Text: Teresa Rodriguez Williamson

Printed in Singapore

Pattern + Palette²

SOURCEBOOK

A Complete Guide to Choosing the
Perfect Color and Pattern in Design

GLOUCESTER MASSACHUSETTS

ROCKPORT PUBLISHERS

Compiled by Heidi Arrizabalaga

Contents

Pattern and Palette Sourcebook 2 is a comprehensive guide to thoughtful color coordination and sophisticated pattern styles. Use this book as an inspiring tool to provide you with unconventional insights into the nature and application of color combination and pattern design. Color preferences are very subjective personal choices, so explore the Technicolor pages of this guide with curiosity and an open mind. Color does not exist without a reference, so the designer, Heidi Arrizabalaga, has used patterns to uncover combinations that encourage you to examine color relationships in the context of design.

The philosophy of this manual is based on interpretation—in this case, the interpretation of the designer. Heidi has created six different color and pattern combinations that are arranged under the chapter titles Modern Enthusiast, Madame Nouveau, Floral Aesthete, Global Maven, Pop Impresario, and Urban Vivant. With these artfully designed palettes, she has created a framework for trends in color and patterns.

Each page showcases five examples of patterns that were developed using two or more of the color samples at the top of the page. By studying and experimenting with these patterns, you can see how any two or more colors work together to create astonishingly different effects. The same coordinated set of colors can say vastly different things, depending on how they are assembled and applied. Use this application as a casebook to help you create interesting color schemes more quickly, accurately, and creatively.

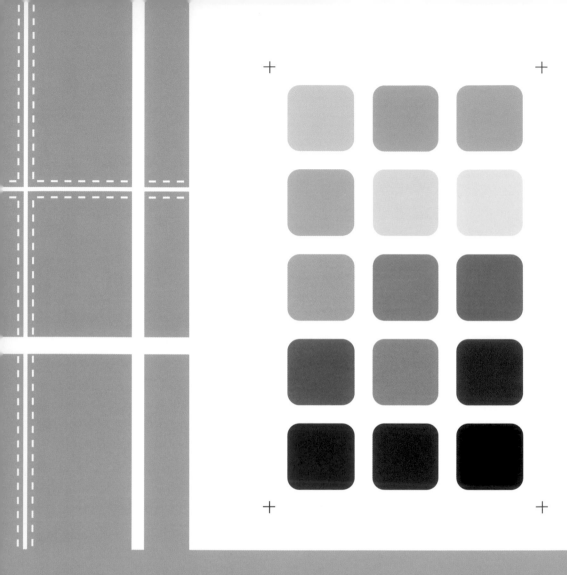

In a time when optimism was the key ingredient of life, the genre we now call "vintage" was born. In these patterns, you get that sense of joy and life, with a modern twist of sophistication. Color plays a critical part in this set of designs. With bright, welcoming shades, each set bursts off the page. And with a gentle shift in color, the patterns change completely—seemingly simple yet delightfully complex.

Modern Enthusiast

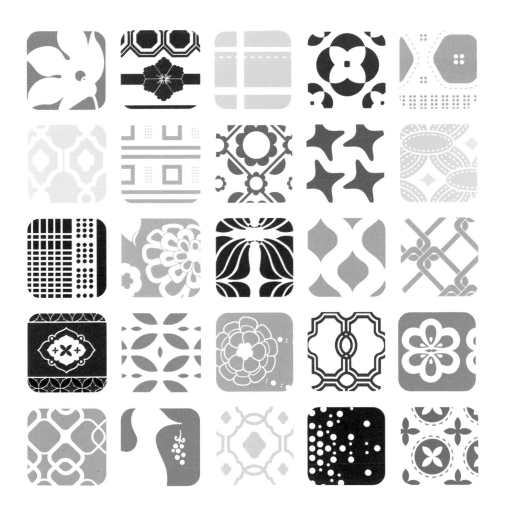

C	0		0		41		25		17
M	52		11		0		3		52
Y	100		70		12		100		87
K	0		0		0		14		63

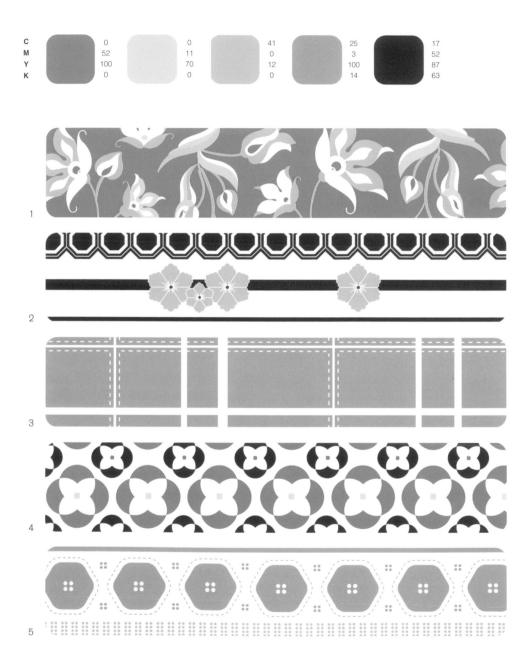

1

2

3

4

5

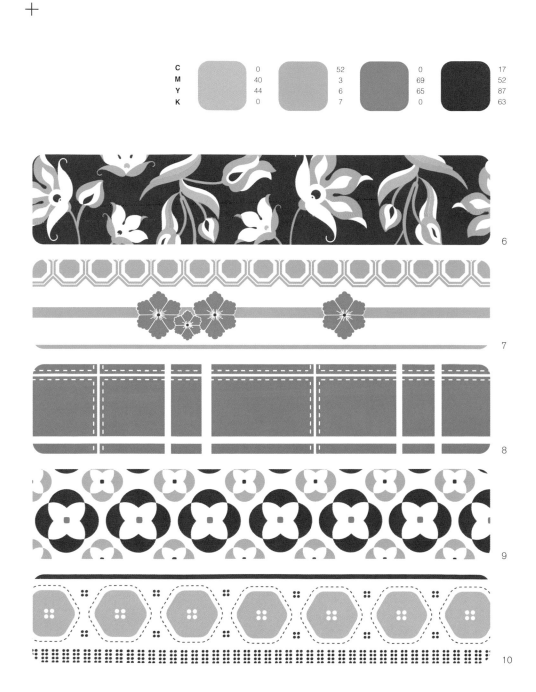

C	0		52		0		17
M	40		3		69		52
Y	44		6		65		87
K	0		7		0		63

6

7

8

9

10

	C	M	Y	K

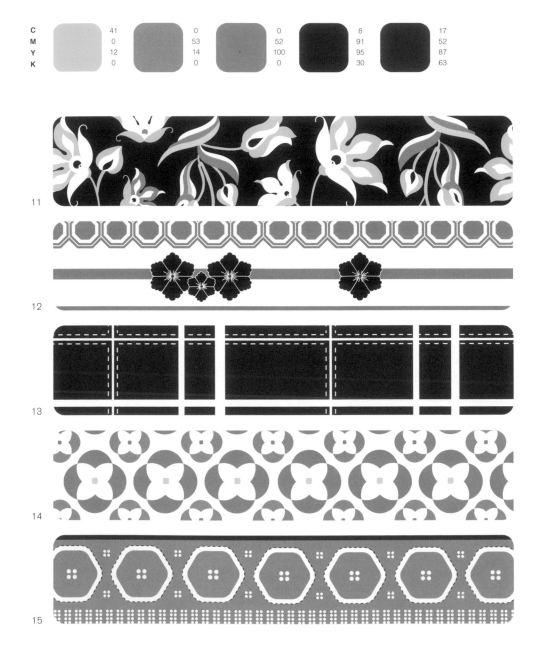

	C		C		C		C		C	
C	41		0		0		8		17	
M	0		53		52		91		52	
Y	12		14		100		95		87	
K	0		0		0		30		63	

11

12

13

14

15

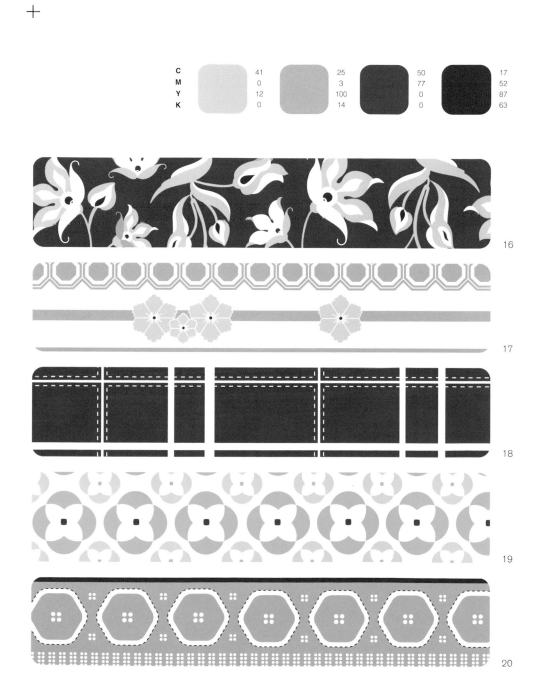

		41		25		50		17
C		41		25		50		17
M		0		3		77		52
Y		12		100		0		87
K		0		14		0		63

16

17

18

19

20

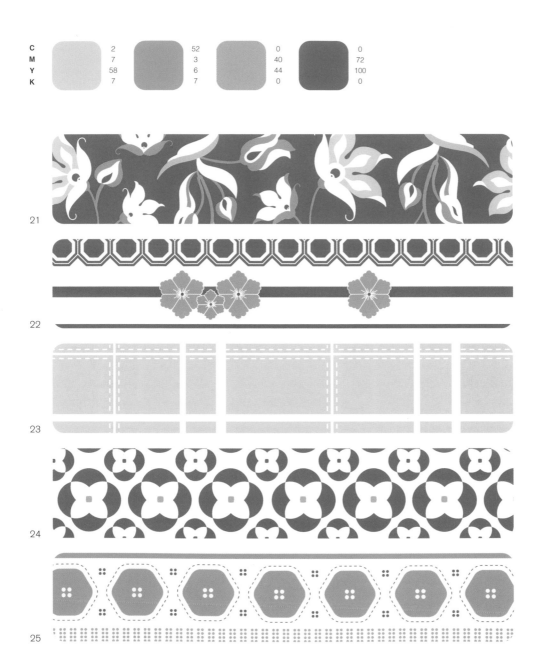

C	2	52	0	0
M	7	3	40	72
Y	58	6	44	100
K	7	7	0	0

21

22

23

24

25

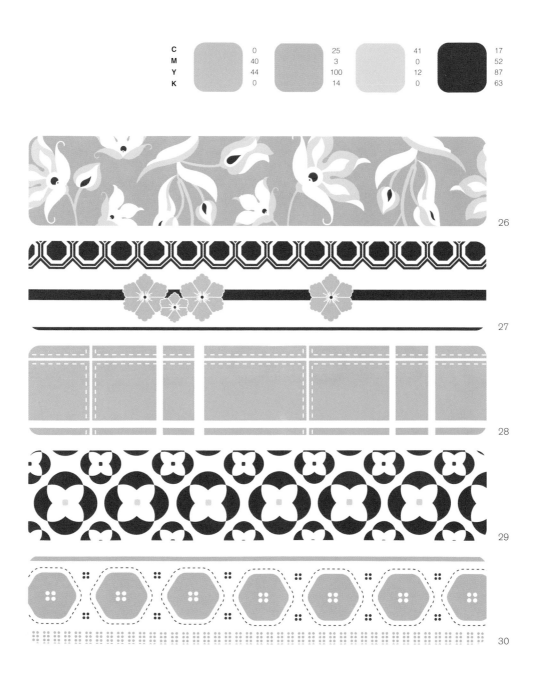

C	0		25		41		17
M	40		3		0		52
Y	44		100		12		87
K	0		14		0		63

26

27

28

29

30

Modern Enthusiast 13

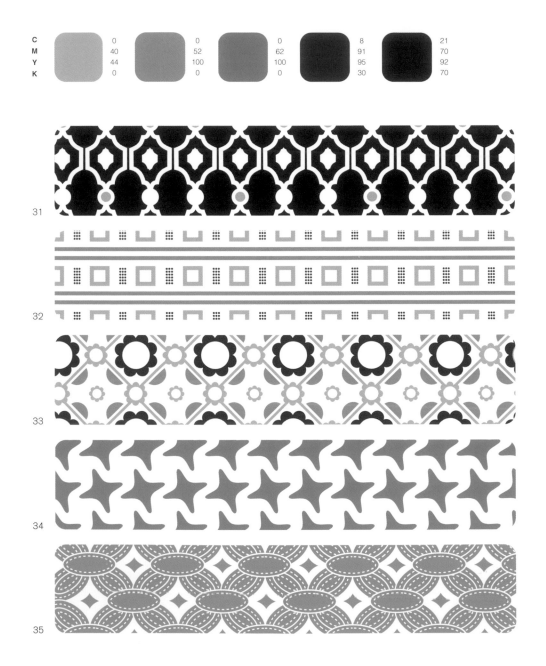

C		0		0		0		8		21
M		40		52		62		91		70
Y		44		100		100		95		92
K		0		0		0		30		70

31

32

33

34

35

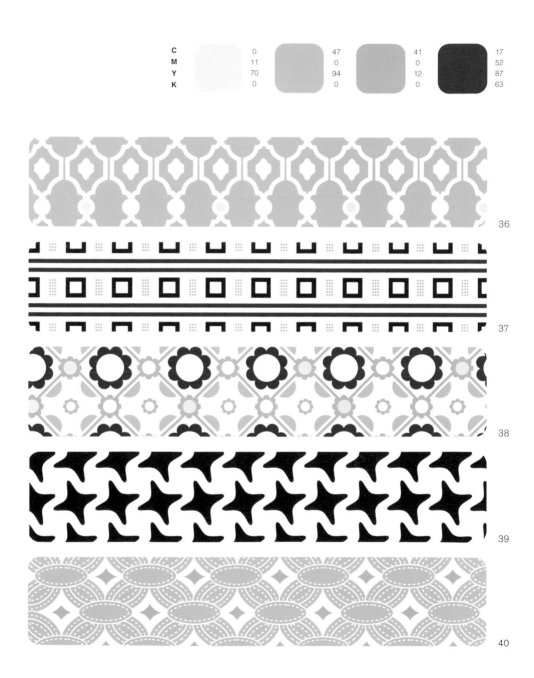

C	0		47		41		17
M	11		0		0		52
Y	70		94		12		87
K	0		0		0		63

36

37

38

39

40

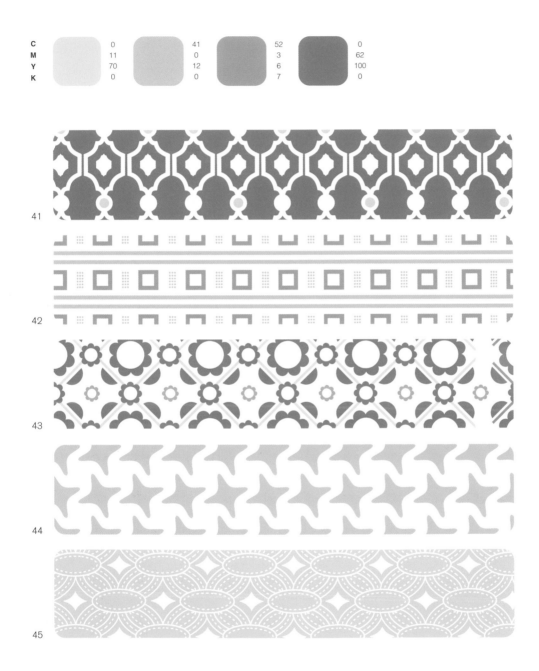

C		0		41		52		0
M		11		0		3		62
Y		70		12		6		100
K		0		0		7		0

41

42

43

44

45

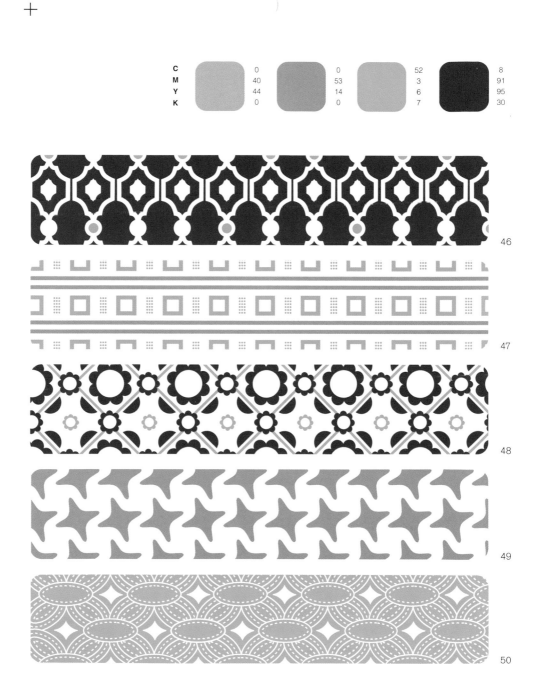

C	0		0		52		8
M	40		53		3		91
Y	44		14		6		95
K	0		0		7		30

46

47

48

49

50

C	0		0		0		17
M	40		53		69		52
Y	44		14		65		87
K	0		0		0		63

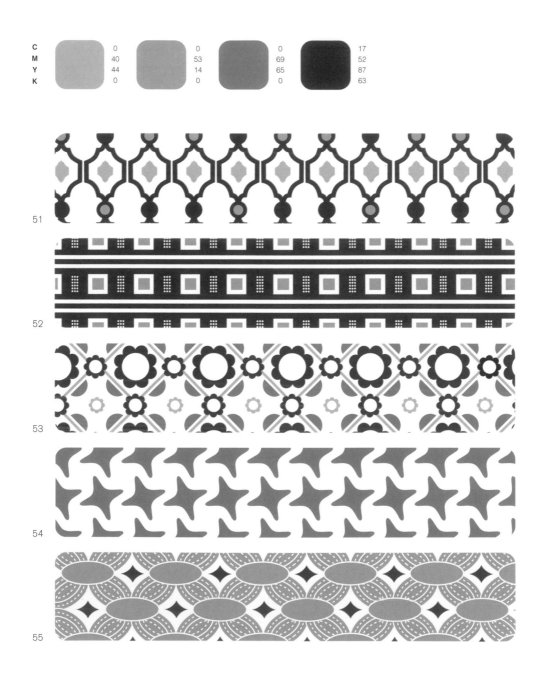

51

52

53

54

55

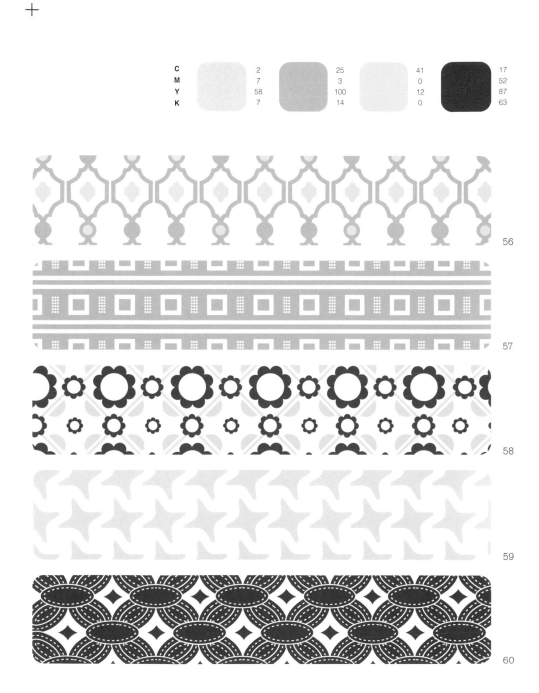

C	2		25		41		17
M	7		3		0		52
Y	58		100		12		87
K	7		14		0		63

56

57

58

59

60

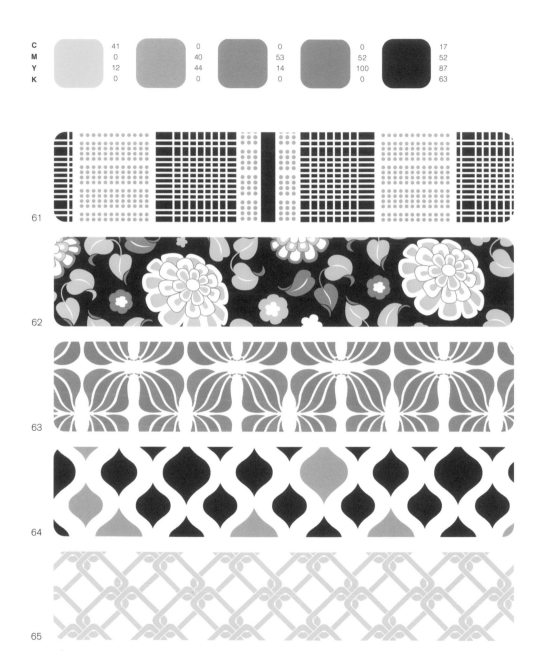

C	41	0	0	0	17
M	0	40	53	52	52
Y	12	44	14	100	87
K	0	0	0	0	63

61

62

63

64

65

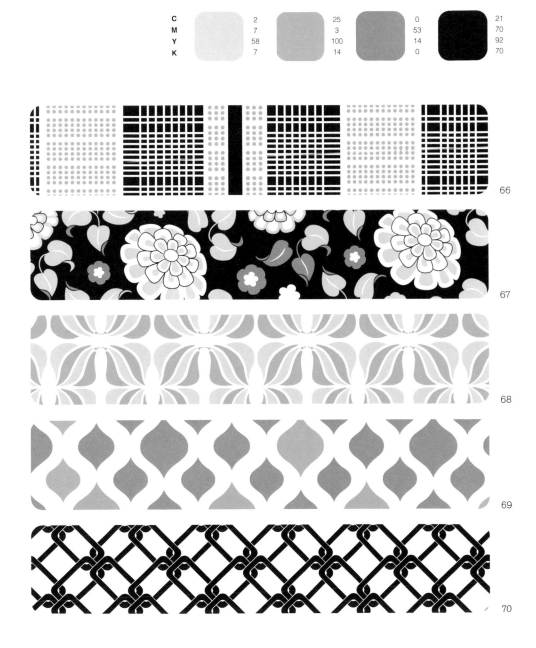

C		2		25		0		21
M		7		3		53		70
Y		58		100		14		92
K		7		14		0		70

66

67

68

69

70

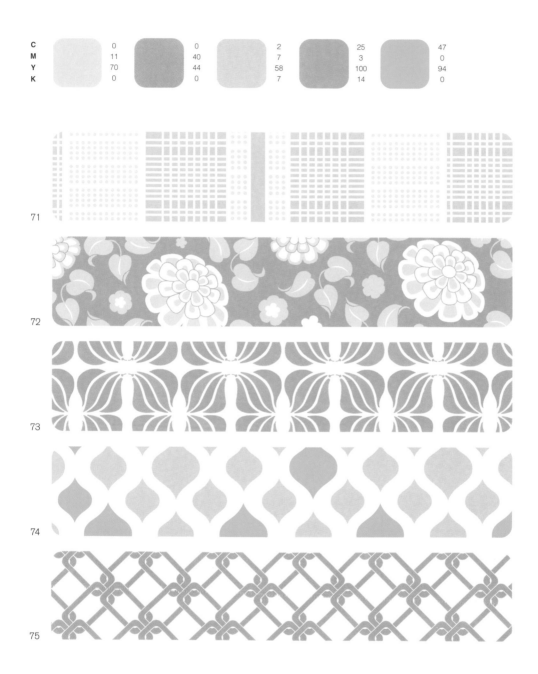

C	0		0		2		25		47
M	11		40		7		3		0
Y	70		44		58		100		94
K	0		0		7		14		0

71

72

73

74

75

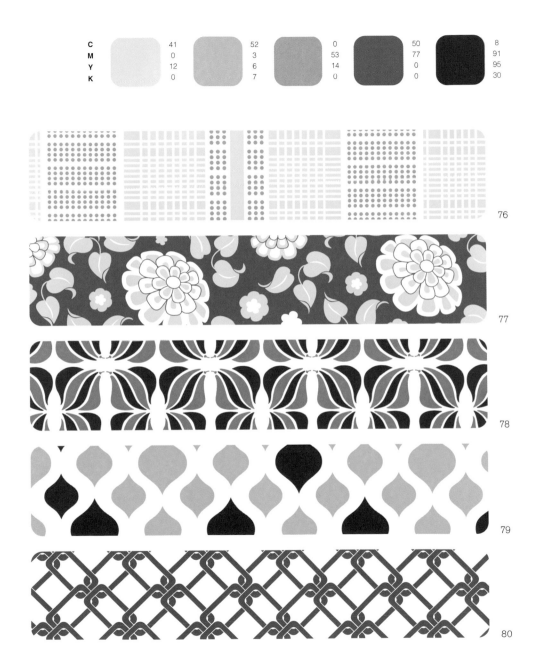

C	41		52		0		50		8
M	0		3		53		77		91
Y	12		6		14		0		95
K	0		7		0		0		30

76

77

78

79

80

C	41		25		0		17
M	0		3		52		52
Y	12		100		100		87
K	0		14		0		63

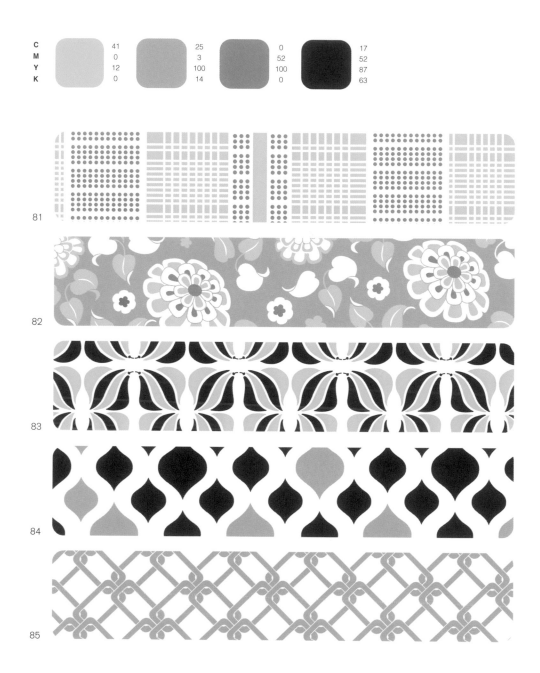

81

82

83

84

85

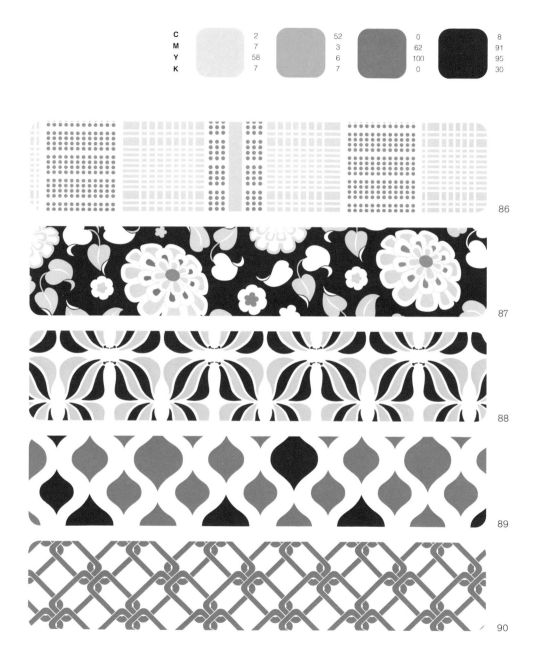

C		2		52		0		8
M		7		3		62		91
Y		58		6		100		95
K		7		7		0		30

86

87

88

89

90

C	41		52		25		0		0		17
M	0		3		3		40		52		52
Y	12		6		100		44		100		87
K	0		7		14		0		0		63

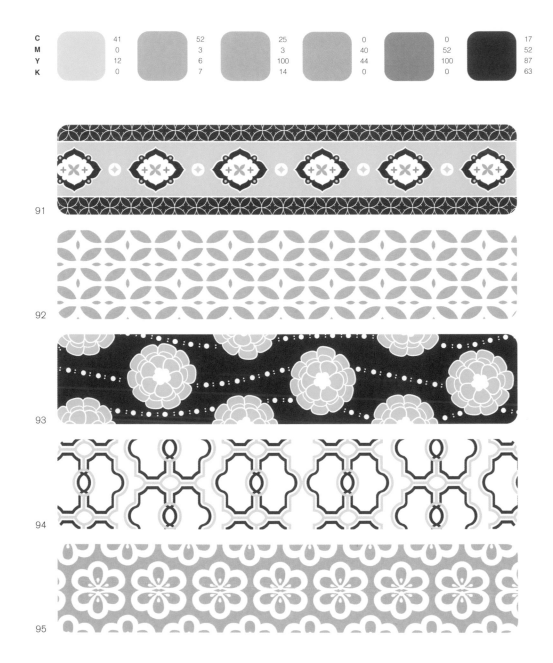

91

92

93

94

95

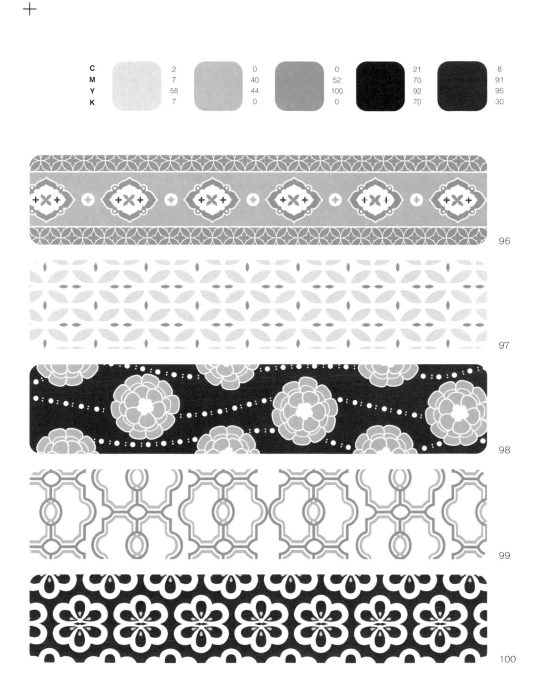

C		2		0		0		21		8
M		7		40		52		70		91
Y		58		44		100		92		95
K		7		0		0		70		30

96

97

98

99

100

C		0		2		41		0		8
M		11		7		0		52		91
Y		70		58		12		100		95
K		0		7		0		0		30

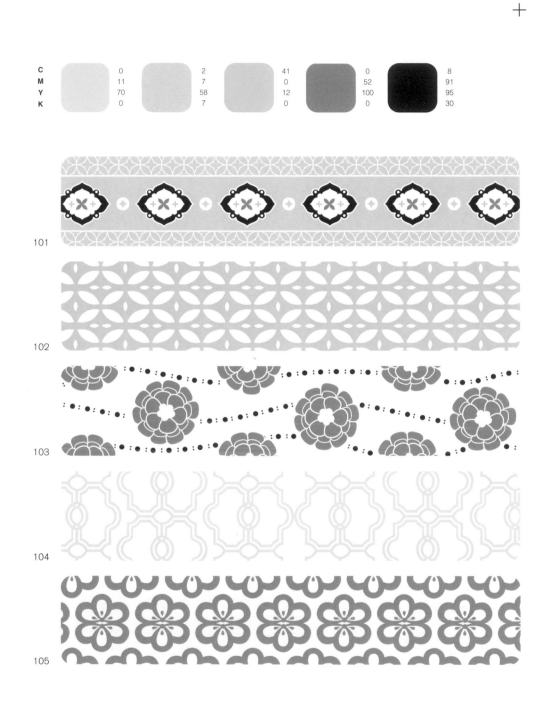

101

102

103

104

105

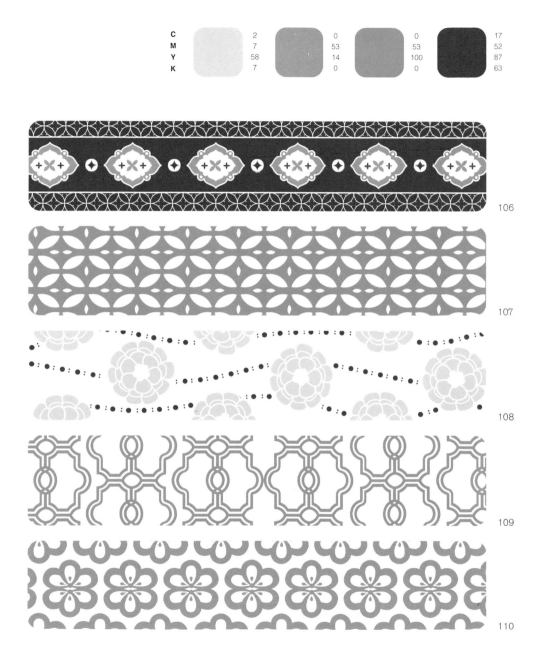

C	2		0		0		17
M	7		53		53		52
Y	58		14		100		87
K	7		0		0		63

106

107

108

109

110

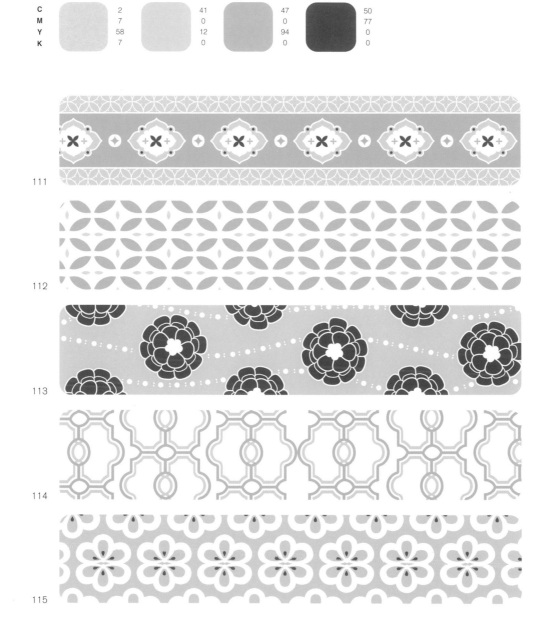

C	2	41	47	50
M	7	0	0	77
Y	58	12	94	0
K	7	0	0	0

111

112

113

114

115

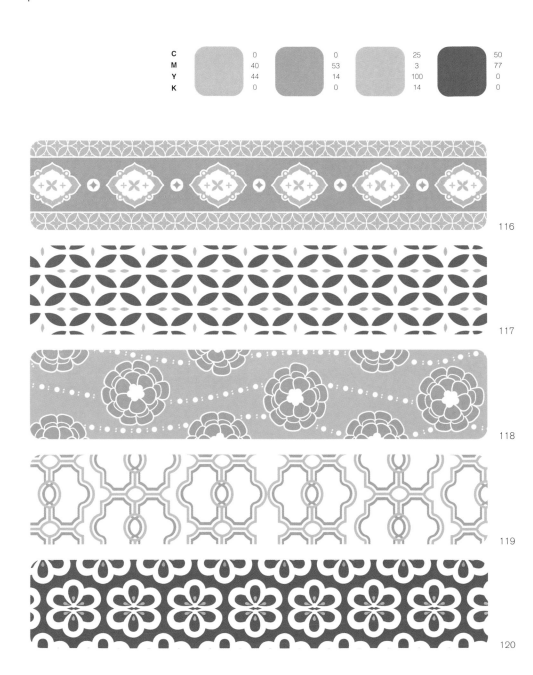

C	0		0		25		50
M	40		53		3		77
Y	44		14		100		0
K	0		0		14		0

116

117

118

119

120

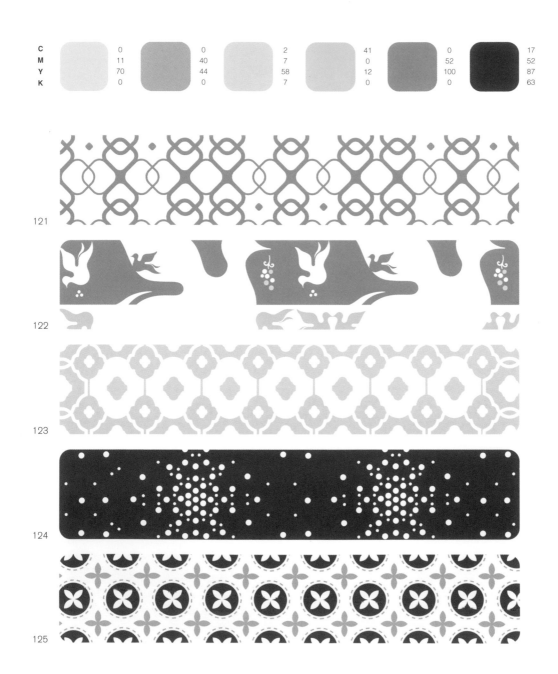

C	0	0	2	41	0	17
M	11	40	7	0	52	52
Y	70	44	58	12	100	87
K	0	0	7	0	0	63

121

122

123

124

125

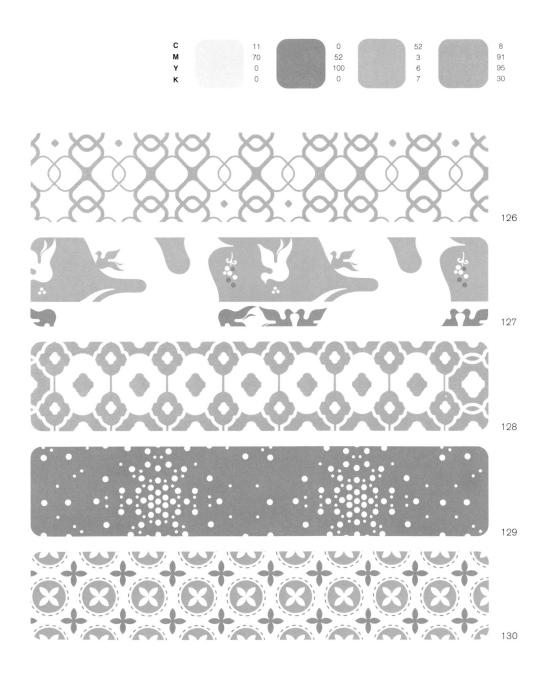

C	11	0	52	8
M	70	52	3	91
Y	0	100	6	95
K	0	0	7	30

126

127

128

129

130

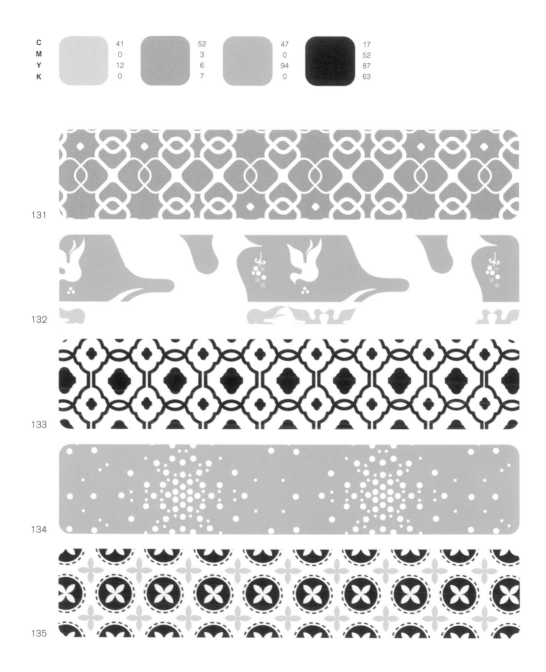

C	41	52	47	17			
M	0	3	0	52			
Y	12	6	94	87			
K	0	7	0	63			

131

132

133

134

135

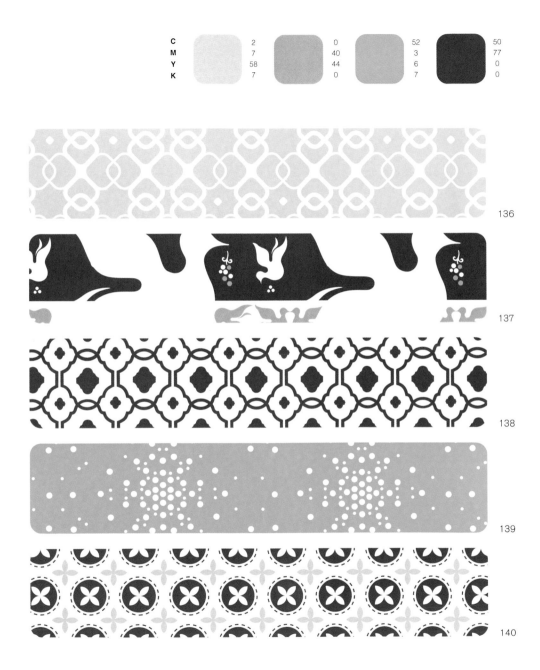

C	2	0	52	50
M	7	40	3	77
Y	58	44	6	0
K	7	0	7	0

136

137

138

139

140

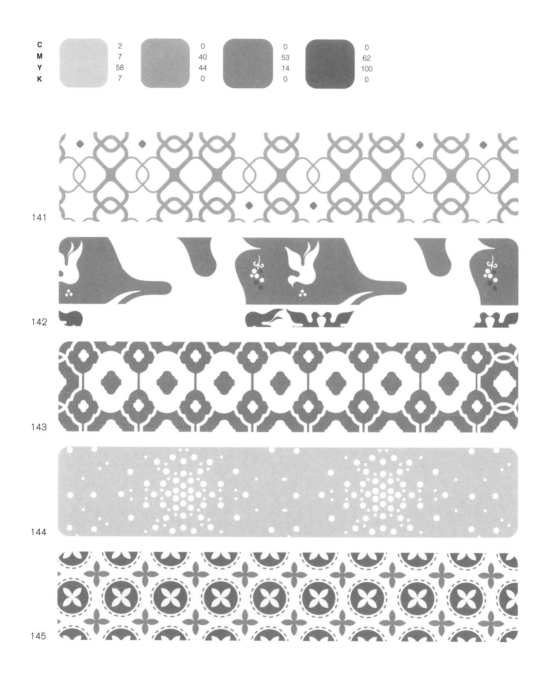

C	2	0	0	0
M	7	40	53	62
Y	58	44	14	100
K	7	0	0	0

141

142

143

144

145

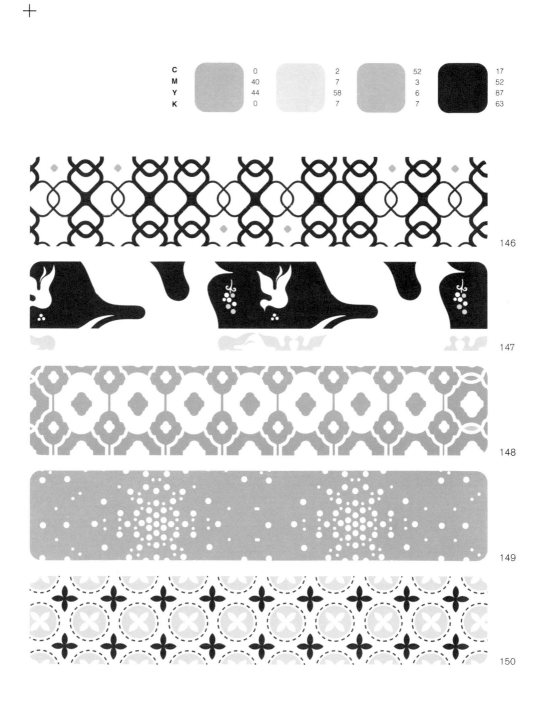

C		0		2		52		17
M		40		7		3		52
Y		44		58		6		87
K		0		7		7		63

146

147

148

149

150

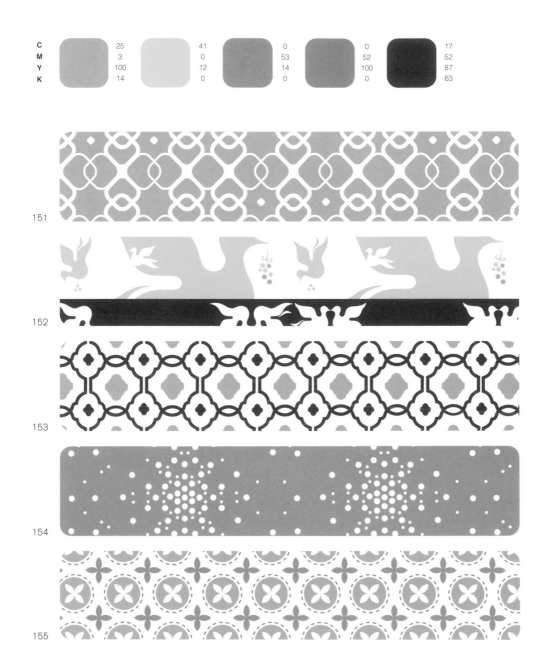

C	25		41		0		0		17
M	3		0		53		52		52
Y	100		12		14		100		87
K	14		0		0		0		63

151

152

153

154

155

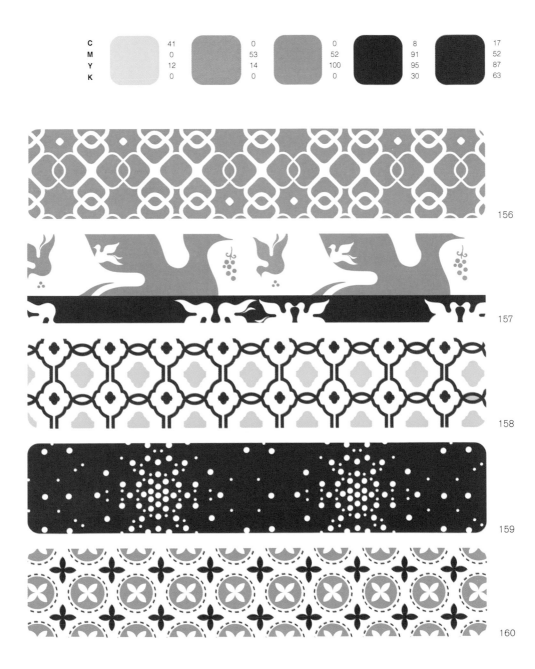

C	41	0	0	8	17
M	0	53	52	91	52
Y	12	14	100	95	87
K	0	0	0	30	63

156

157

158

159

160

When Art Nouveau took center stage in the design world, it became one of the most influential styles of the twentieth century. Unlike past movements that relied on history for their inspiration, Art Nouveau found meaning in everyday, sensual moments. The visionaries of this movement fused the glorious simplicities of life, from peaceful stillness in nature to dramatic modern architecture, into art.

Madame Nouveau

+

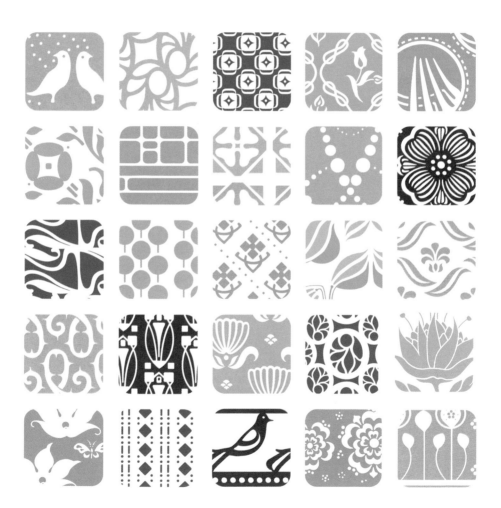

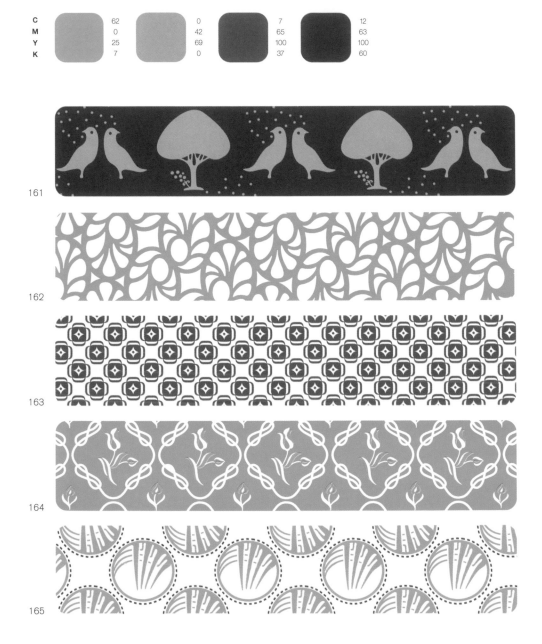

C	62		0		7		12
M	0		42		65		63
Y	25		69		100		100
K	7		0		37		60

161

162

163

164

165

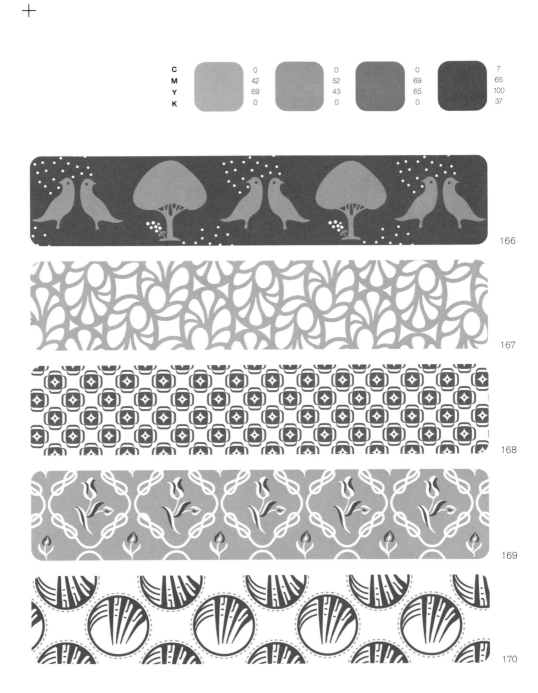

C 0	0	0	7
M 42	52	69	65
Y 69	43	65	100
K 0	0	0	37

166

167

168

169

170

C	40	62	11	30
M	0	0	4	4
Y	17	25	100	85
K	0	7	25	30

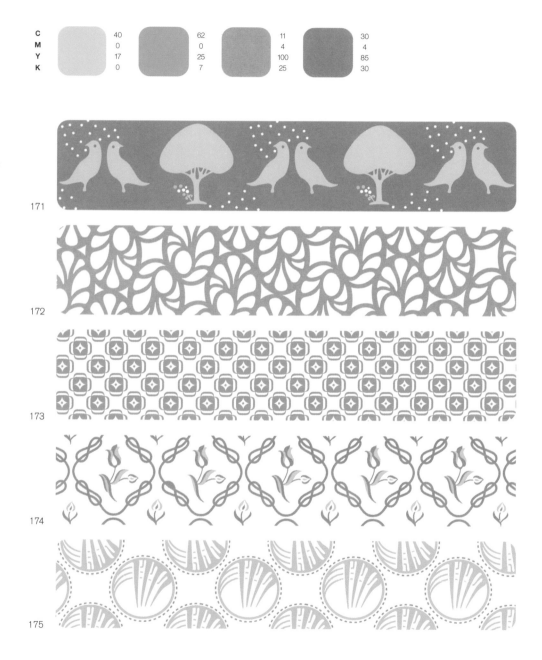

171

172

173

174

175

C	62		0		11		12
M	0		33		4		63
Y	25		75		100		100
K	7		0		25		61

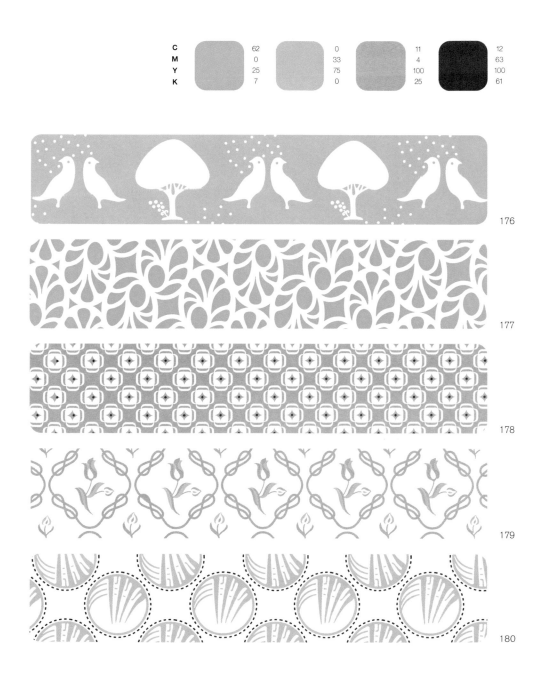

176

177

178

179

180

C		17		11		0		12
M		1		4		33		63
Y		45		100		75		100
K		3		25		0		61

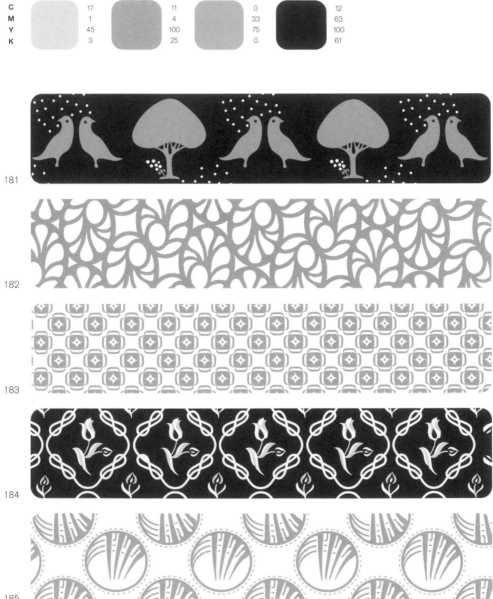

181

182

183

184

185

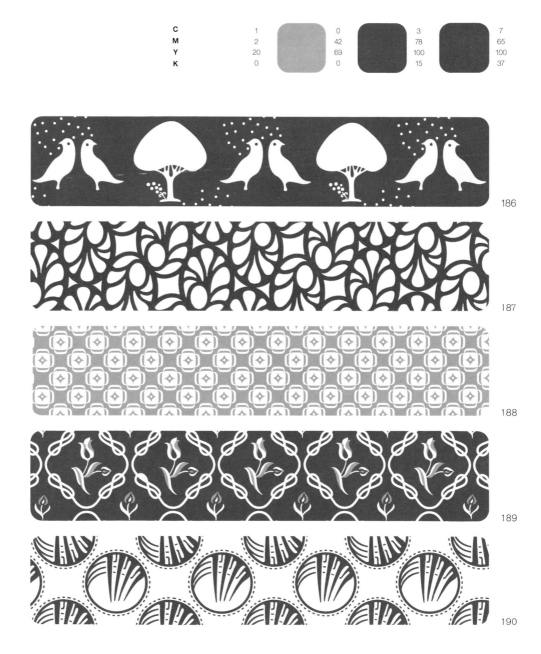

C	1		0		3		7
M	2		42		78		65
Y	20		69		100		100
K	0		0		15		37

186

187

188

189

190

C	0	17	11	30
M	52	1	4	4
Y	43	45	100	85
K	0	3	25	30

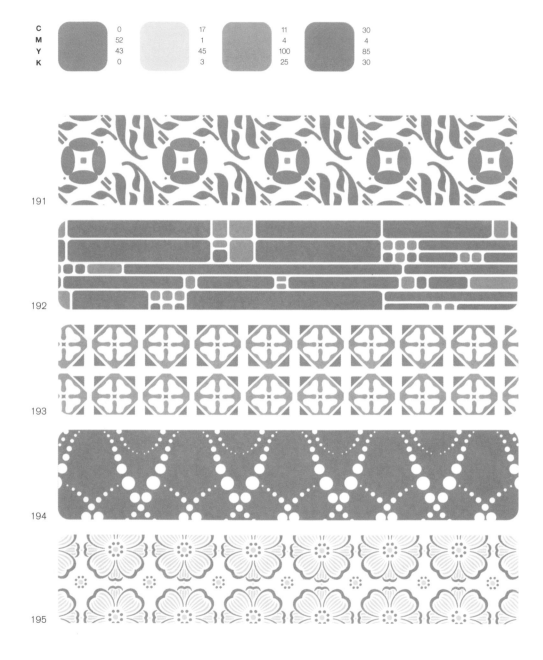

191

192

193

194

195

C		0		62		17		11
M		42		0		1		4
Y		69		25		45		100
K		0		7		3		25

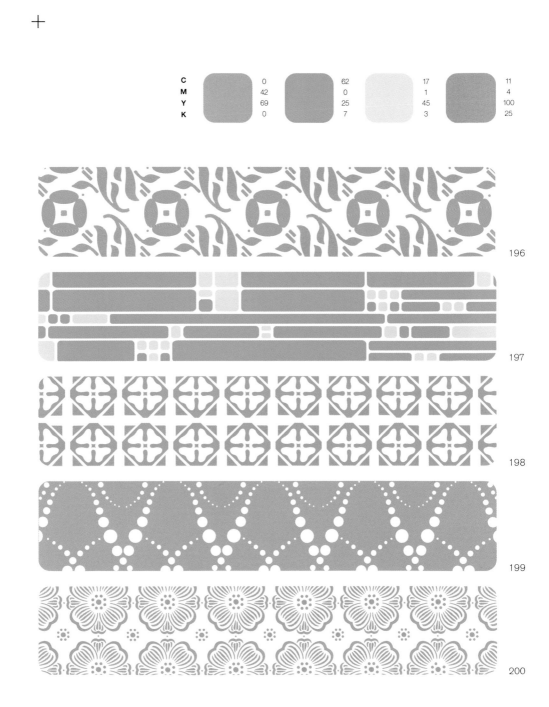

196

197

198

199

200

C	17		40		30		12
M	1		0		4		63
Y	45		17		85		100
K	3		0		30		61

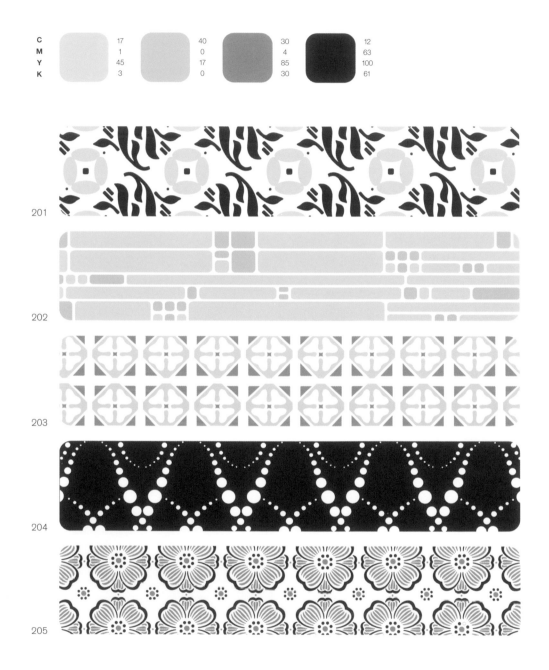

201

202

203

204

205

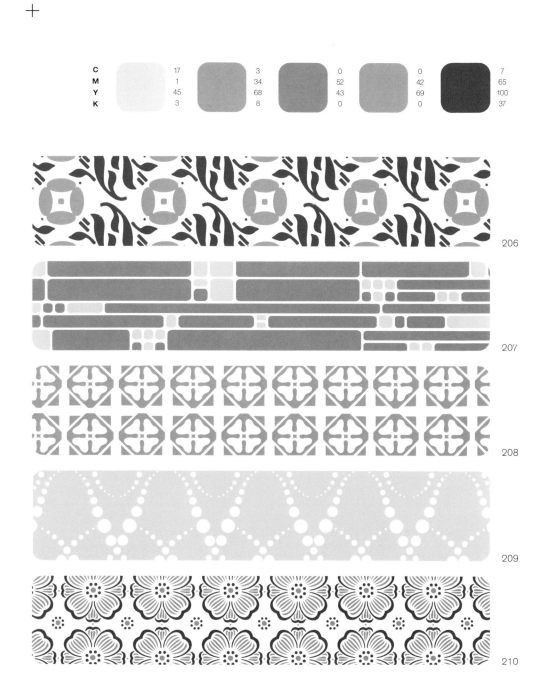

C	17		3		0		0		7
M	1		34		52		42		65
Y	45		68		43		69		100
K	3		8		0		0		37

206

207

208

209

210

C		1		40		0		7
M		2		0		69		65
Y		20		17		65		100
K		0		0		0		37

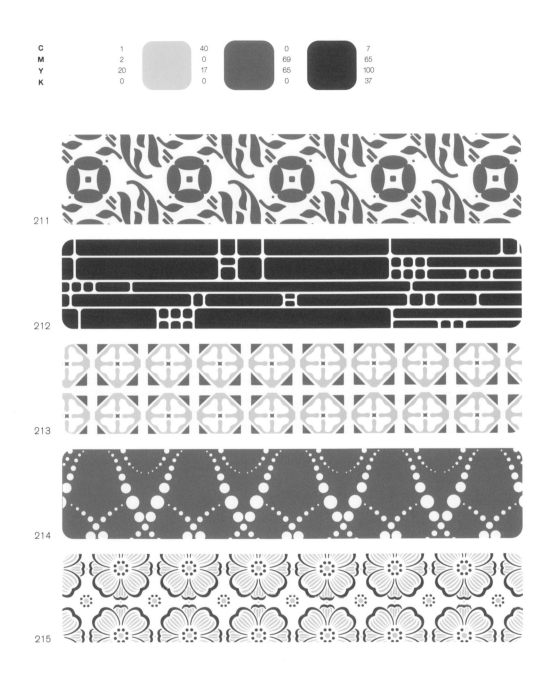

211

212

213

214

215

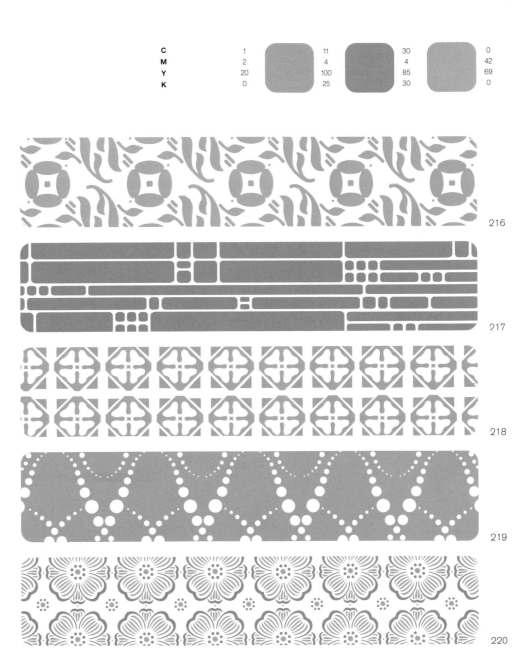

C	1	11	0
M	2	4	42
Y	20	100	69
K	0	25	0

216

217

218

219

220

C	1		62		0		7
M	2		0		33		65
Y	20		25		75		100
K	0		7		0		37

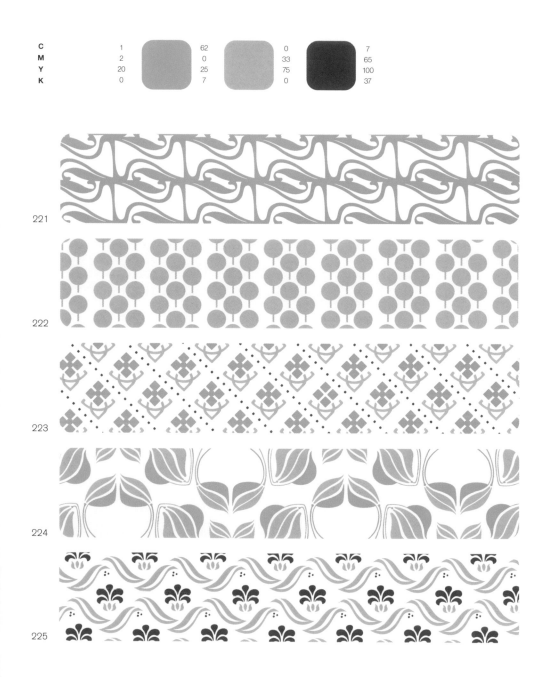

221

222

223

224

225

C	1	0	11	30	0
M	2	52	4	4	42
Y	20	43	100	85	69
K	0	0	25	30	0

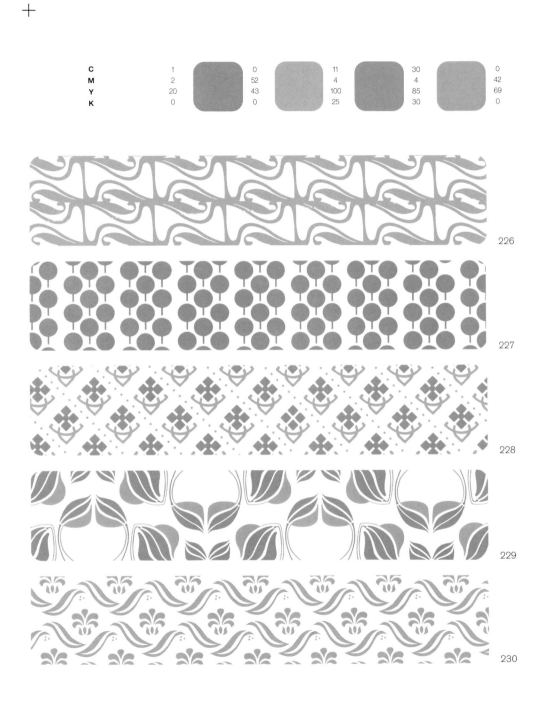

226

227

228

229

230

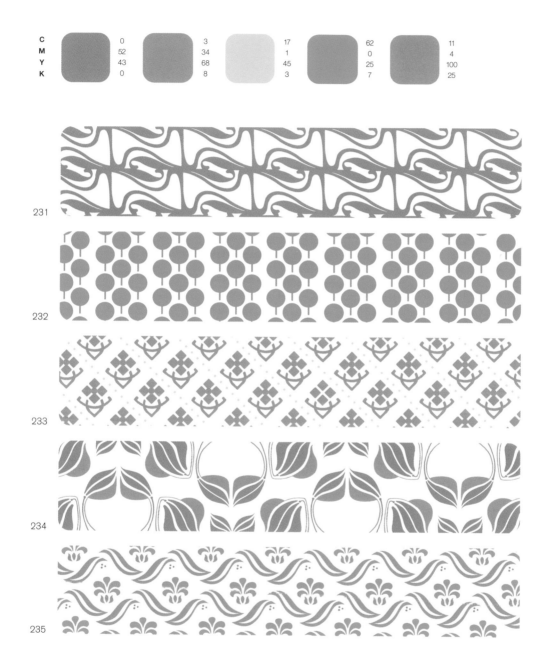

C	0	3	17	62	11
M	52	34	1	0	4
Y	43	68	45	25	100
K	0	8	3	7	25

231

232

233

234

235

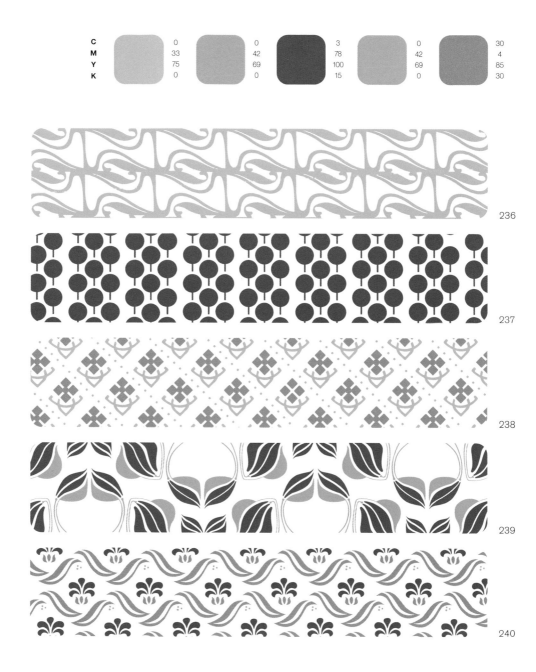

C	0	0	3	0	30
M	33	42	78	42	4
Y	75	69	100	69	85
K	0	0	15	0	30

236

237

238

239

240

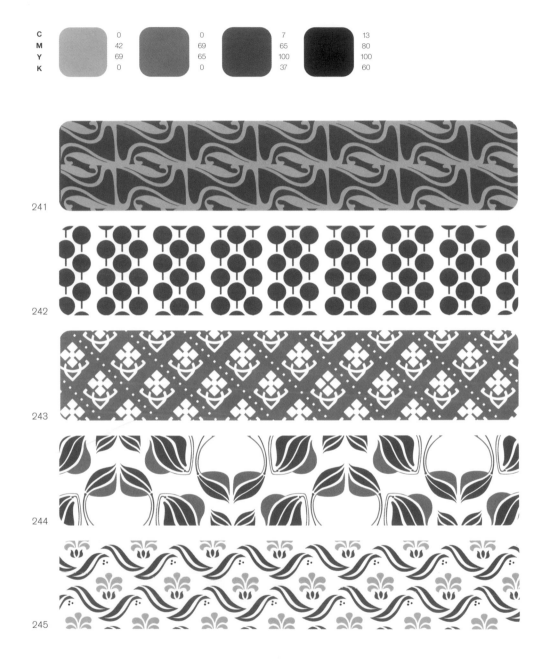

C	0	0	7	13
M	42	69	65	80
Y	69	65	100	100
K	0	0	37	60

241

242

243

244

245

C								
M	40		11		30		12	
Y	0		4		4		63	
K	17		100		85		100	
	0		25		30		61	

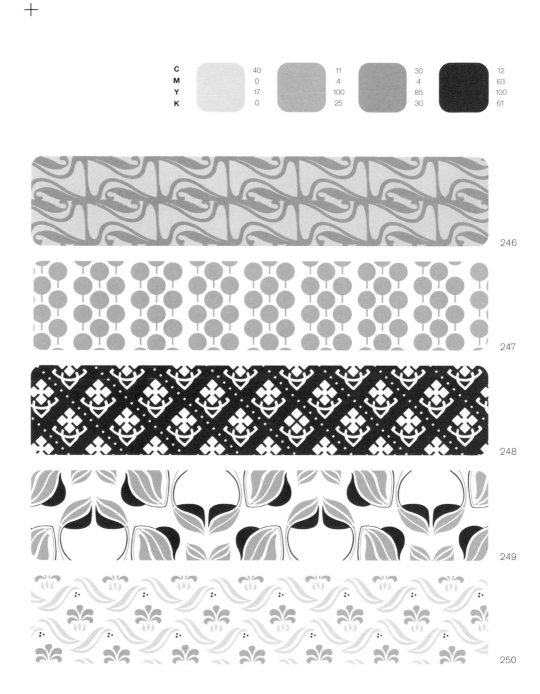

246

247

248

249

250

C	1		40		11		30		12
M	2		0		4		4		63
Y	20		17		100		85		100
K	0		0		25		30		61

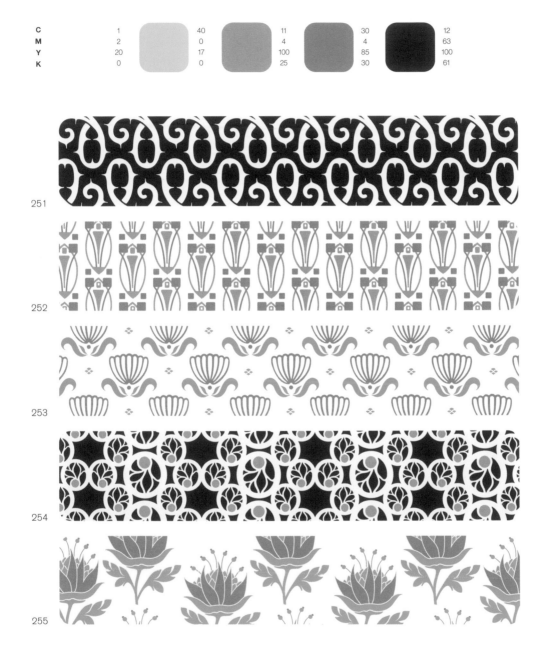

251

252

253

254

255

C	1	40	0	7
M	2	0	42	65
Y	20	17	69	100
K	0	0	0	37

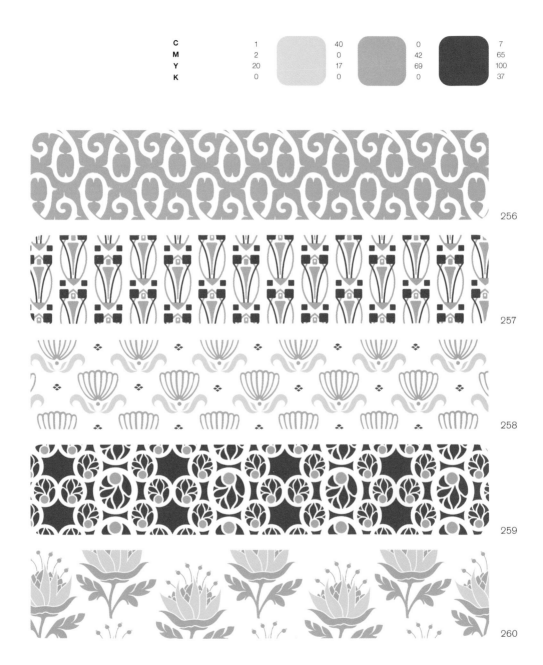

256

257

258

259

260

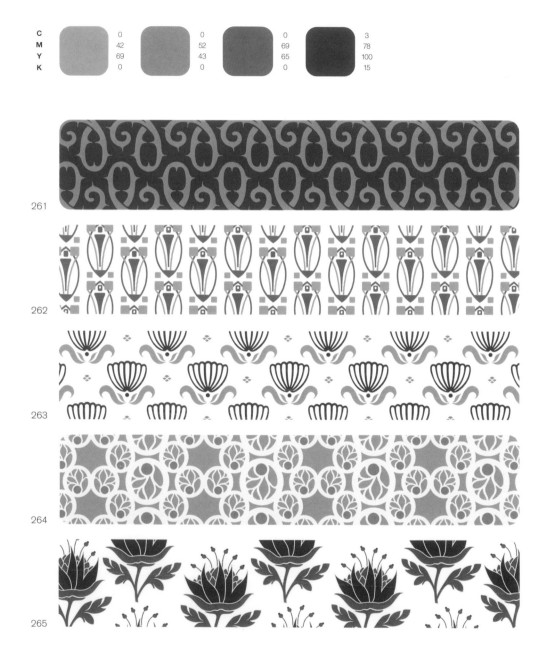

C	0	0	0	3
M	42	52	69	78
Y	69	43	65	100
K	0	0	0	15

261

262

263

264

265

C	17		30		0		13
M	1		4		52		80
Y	45		8		43		100
K	3		30		0		60

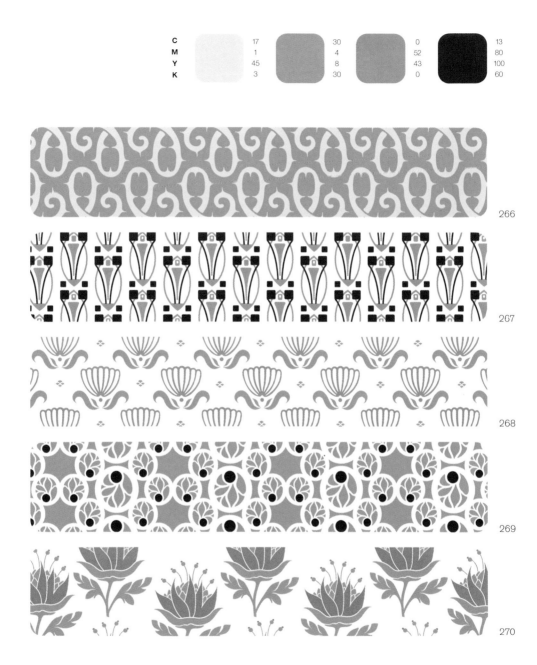

266

267

268

269

270

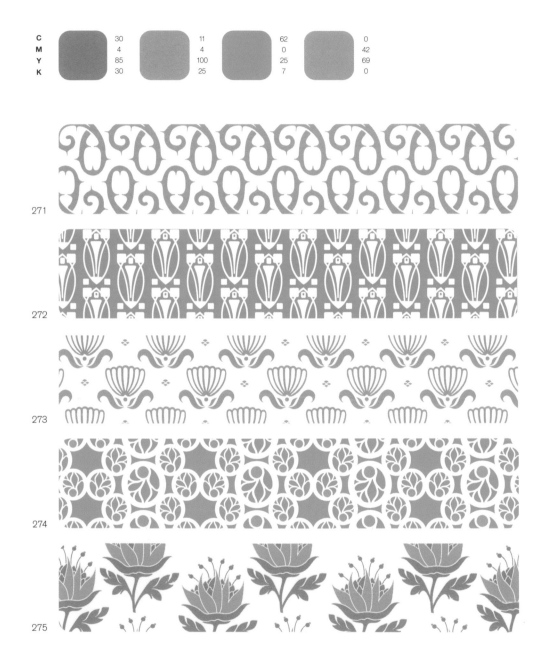

C	30		11		62		0
M	4		4		0		42
Y	85		100		25		69
K	30		25		7		0

271

272

273

274

275

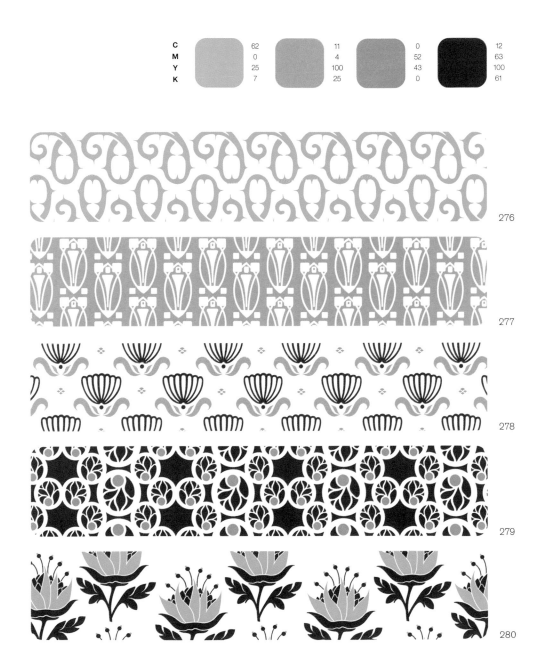

		62		11		0		12
C		62		11		0		12
M		0		4		52		63
Y		25		100		43		100
K		7		25		0		61

276

277

278

279

280

C	1		11		30		40		12
M	2		4		4		0		63
Y	20		100		85		17		100
K	0		25		30		0		61

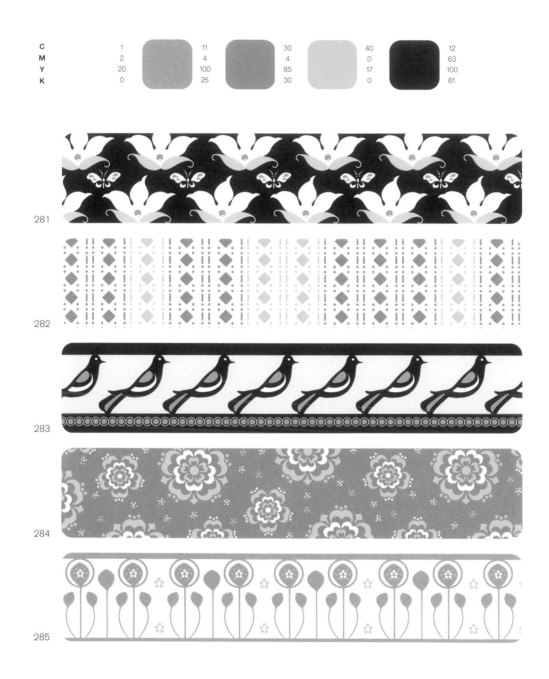

281

282

283

284

285

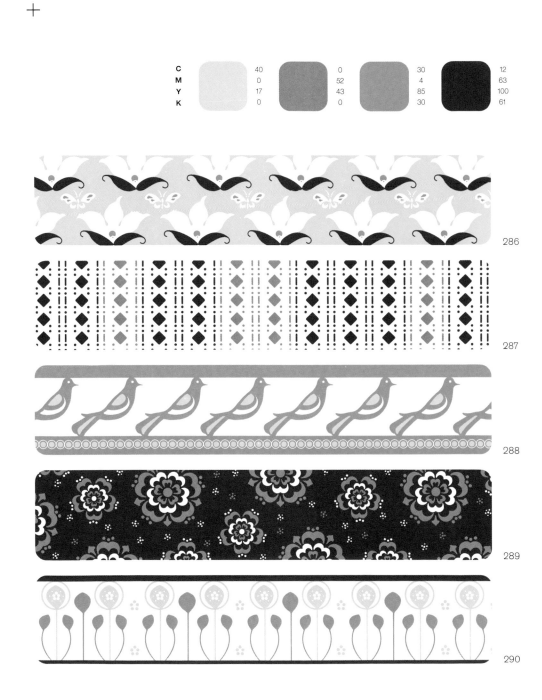

C	40		0		30		12
M	0		52		4		63
Y	17		43		85		100
K	0		0		30		61

286

287

288

289

290

C	40		0		11		30		13
M	0		52		4		4		80
Y	17		43		100		85		100
K	0		0		25		30		60

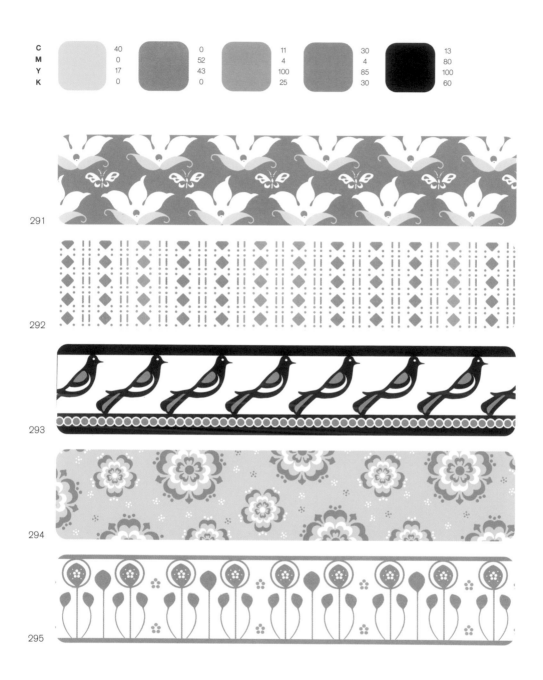

291

292

293

294

295

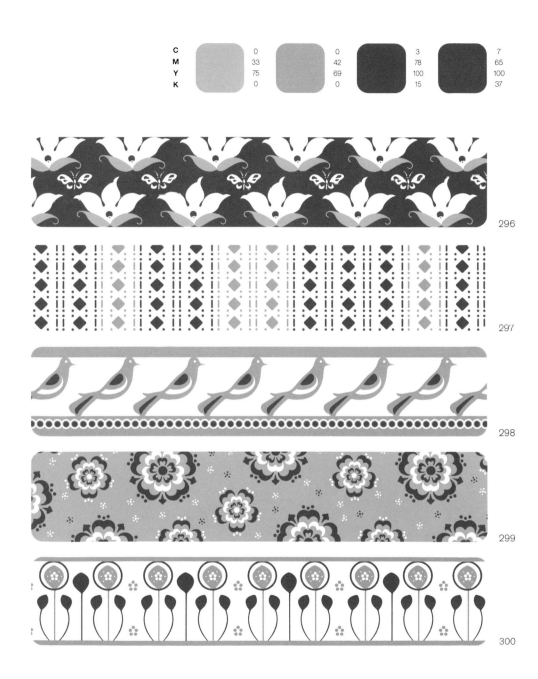

C	0		0		3		7
M	33		42		78		65
Y	75		69		100		100
K	0		0		15		37

296

297

298

299

300

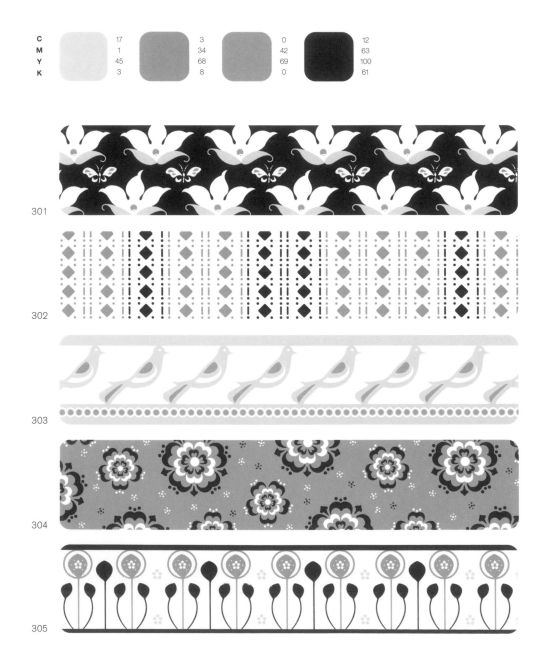

C	17		3		0		12
M	1		34		42		63
Y	45		68		69		100
K	3		8		0		61

301

302

303

304

305

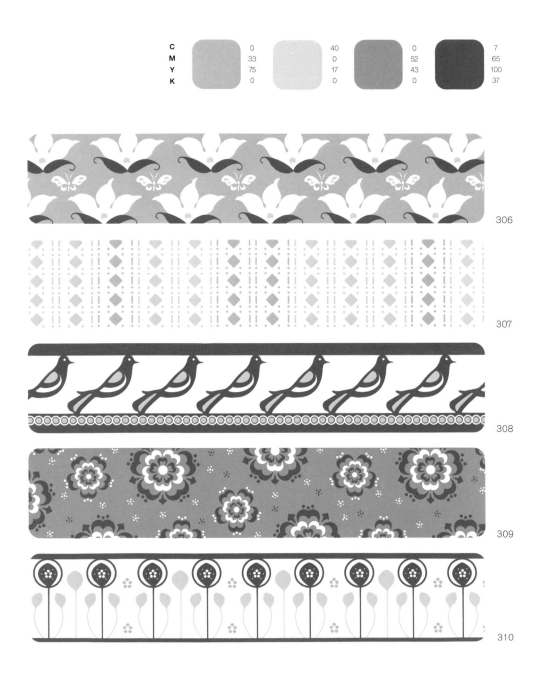

C	0		40		0		7
M	33		0		52		65
Y	75		17		43		100
K	0		0		0		37

306

307

308

309

310

C	17		11		62		30		12
M	1		4		0		4		63
Y	45		100		25		85		100
K	3		25		7		30		61

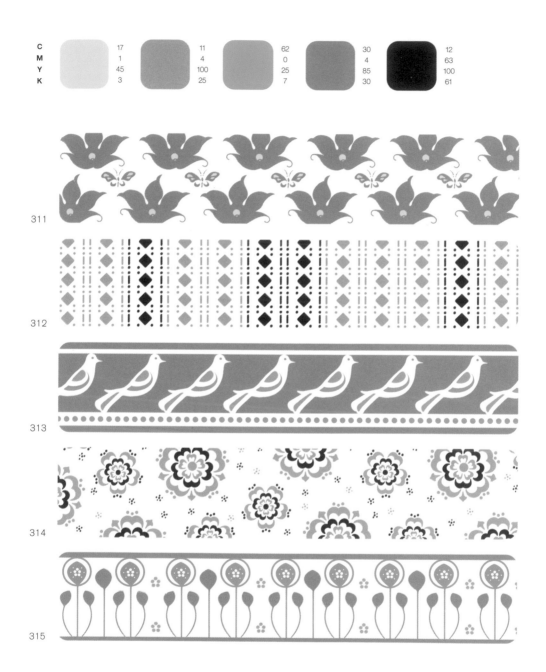

311

312

313

314

315

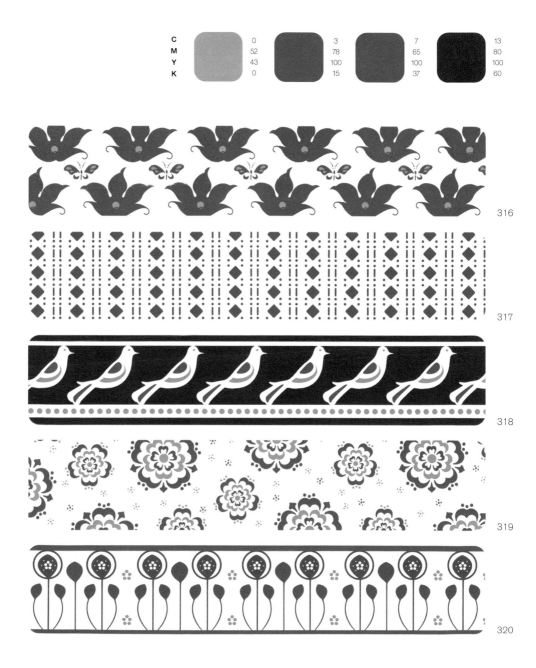

C	0		3		7		13
M	52		78		65		80
Y	43		100		100		100
K	0		15		37		60

316

317

318

319

320

Stepping away from the traditional floral motifs and moving into a design space where nature meets nurtured style, we get Floral Aesthete. Notice the grand floral shapes embellished in rich, decadent colors. Many of the shades used here create an essence of masculine beauty. Still employing a consistent pattern, the designs seem to move and evolve simply by changing the color palette. See how you can take typically feminine artwork and transform it with color.

Floral Aesthete

C	3		47		52		33		17
M	2		0		6		0		44
Y	62		94		79		17		59
K	5		0		25		0		49

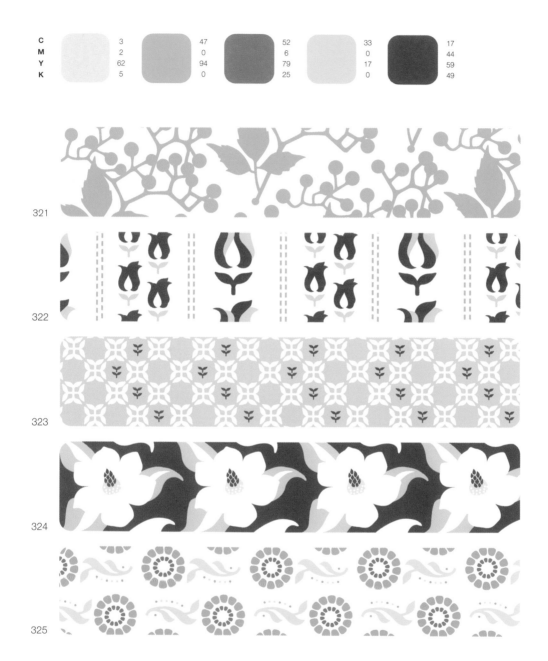

321

322

323

324

325

C	33		25		52		14		43
M	0		0		6		71		90
Y	17		55		79		0		0
K	0		0		25		0		0

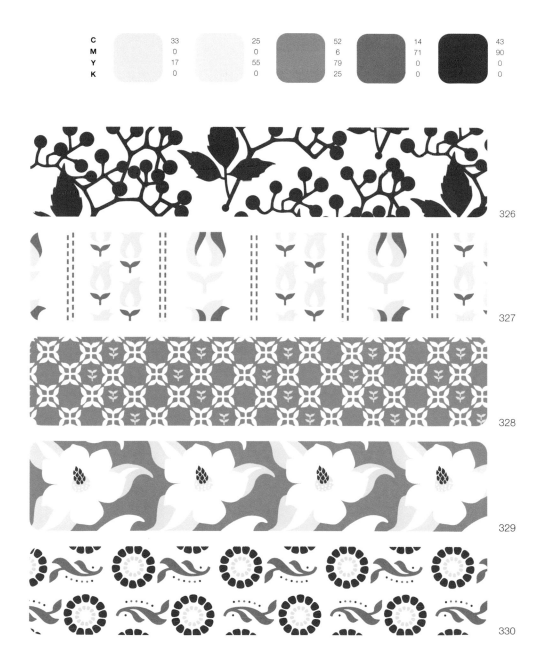

326

327

328

329

330

C		0		25		47		49
M		34		0		0		13
Y		54		55		94		98
K		0		0		0		62

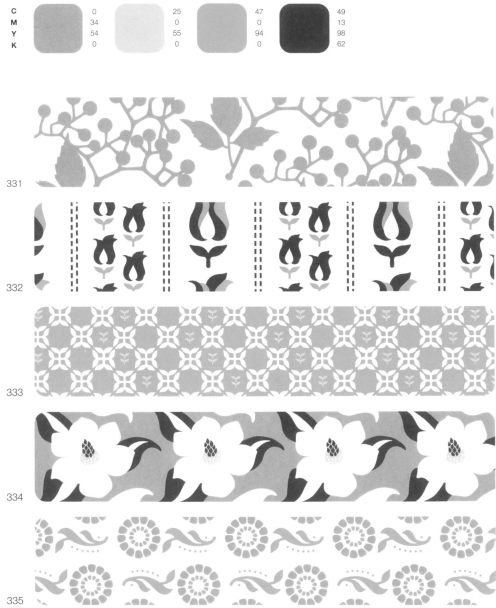

331

332

333

334

335

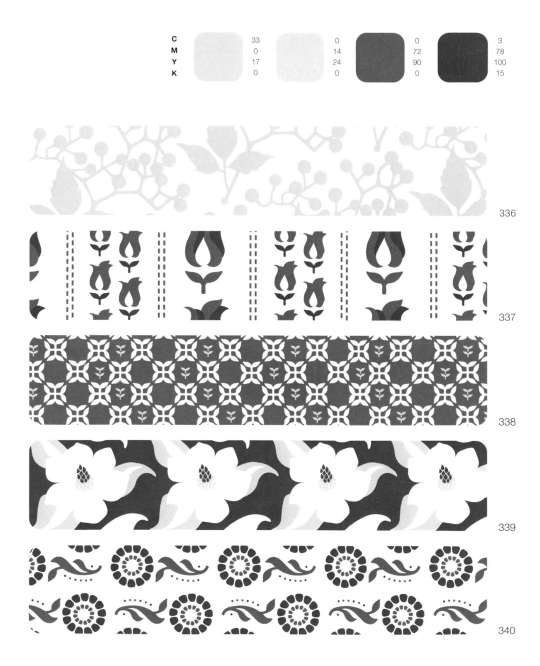

C	33	0	0	3
M	0	14	72	78
Y	17	24	90	100
K	0	0	0	15

336

337

338

339

340

C		0		27		47		52		42
M		13		0		0		6		13
Y		78		55		94		79		98
K		0		0		0		25		61

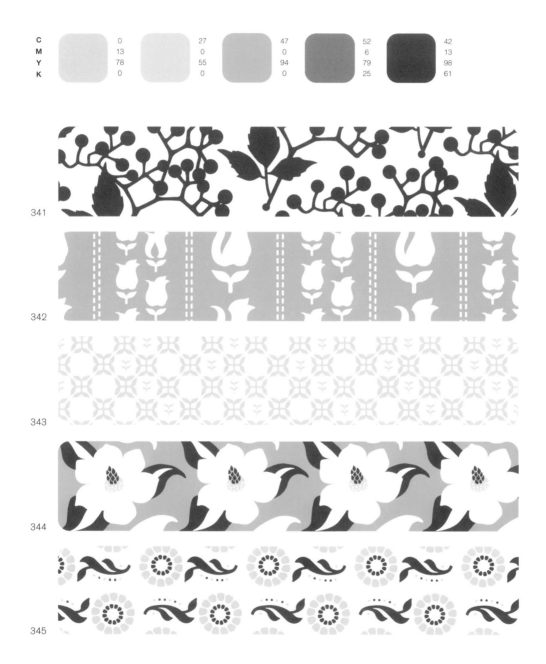

341

342

343

344

345

C	3		0		17		12
M	2		34		44		63
Y	62		54		59		100
K	5		0		49		61

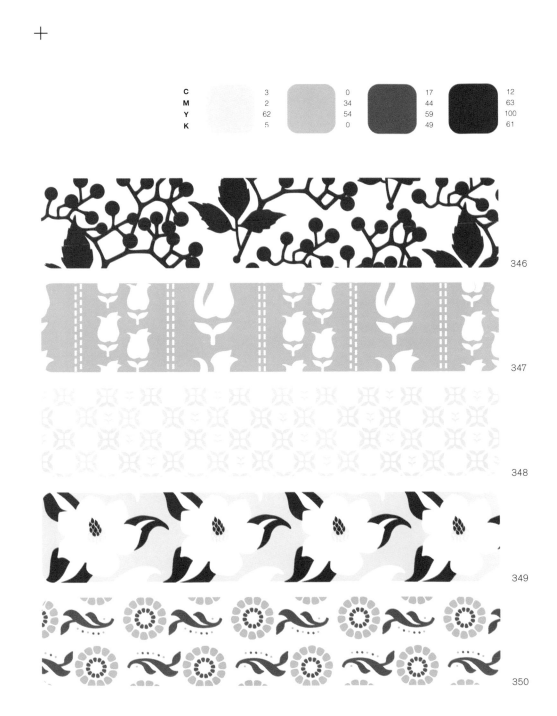

346

347

348

349

350

C		3		33		27		47		17
M		2		0		0		0		44
Y		62		17		55		94		59
K		5		0		0		0		49

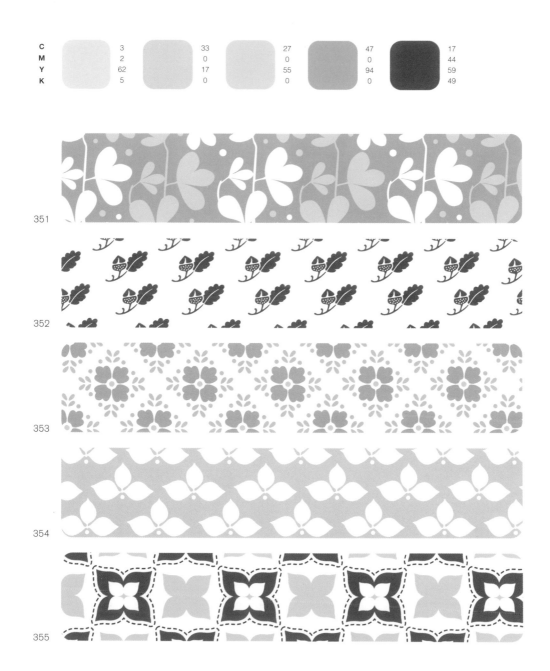

351

352

353

354

355

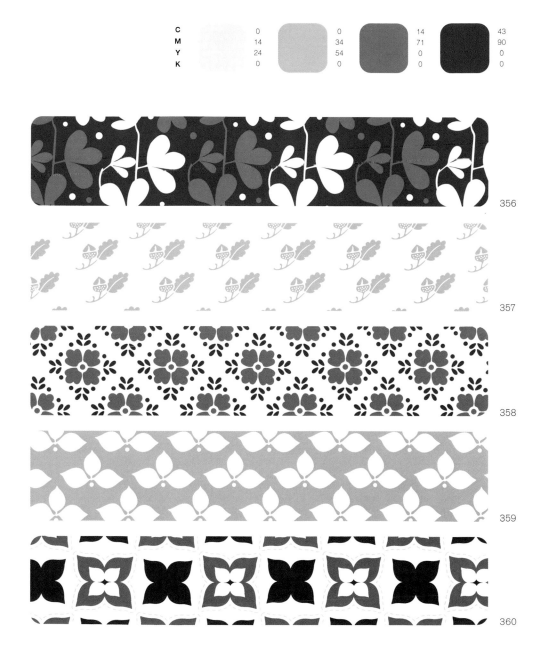

C	0	0	14	43
M	14	34	71	90
Y	24	54	0	0
K	0	0	0	0

356

357

358

359

360

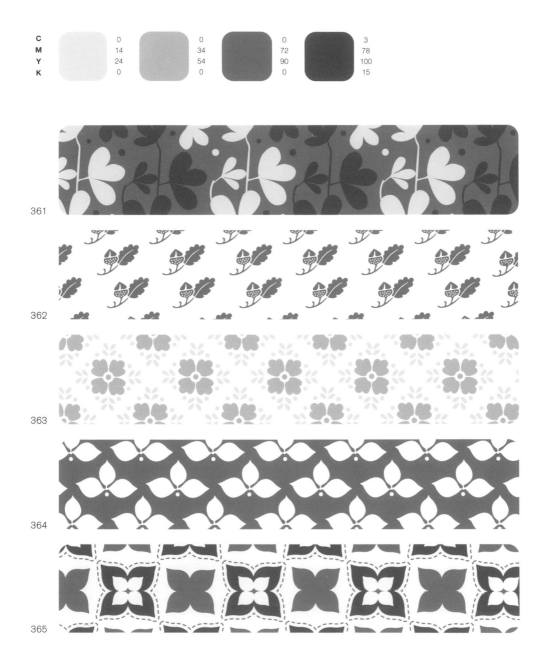

C		0		0		0		3
M		14		34		72		78
Y		24		54		90		100
K		0		0		0		15

361

362

363

364

365

C	33		27		52		49
M	0		0		6		13
Y	17		55		79		98
K	0		0		25		62

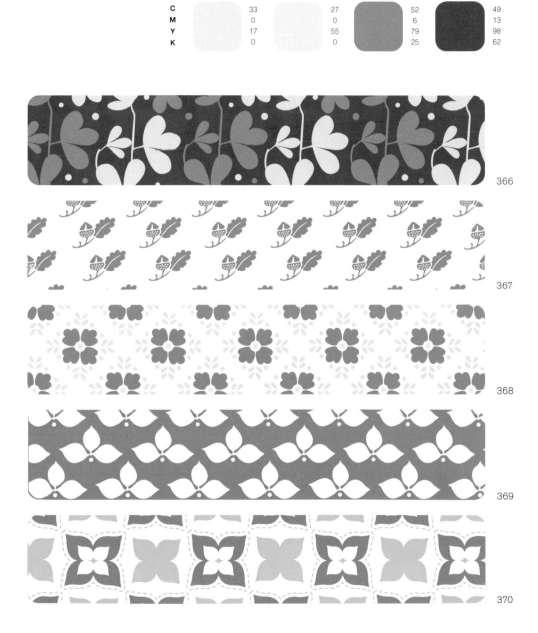

366

367

368

369

370

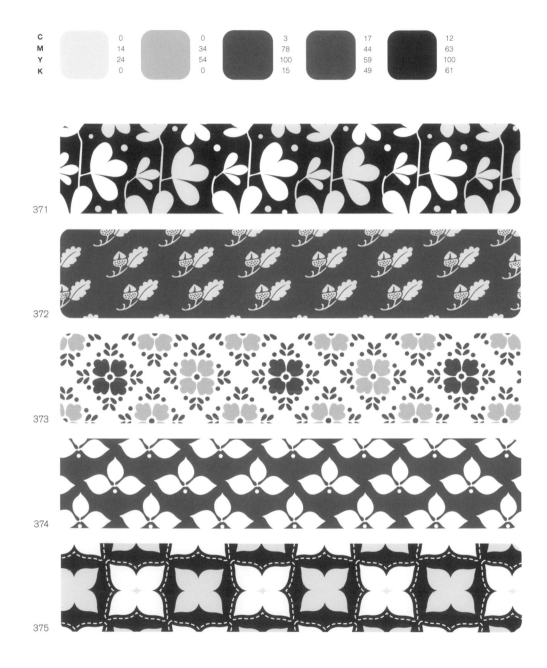

C	0	0	3	17	12
M	14	34	78	44	63
Y	24	54	100	59	100
K	0	0	15	49	61

371

372

373

374

375

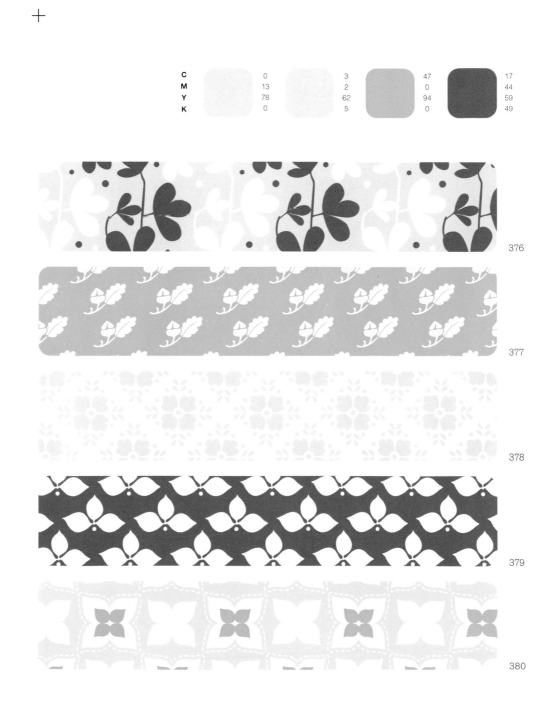

C	0		3		47		17
M	13		2		0		44
Y	78		62		94		59
K	0		5		0		49

376

377

378

379

380

C	0		0		33		27		49
M	14		34		0		0		13
Y	24		54		17		55		98
K	0		0		0		0		62

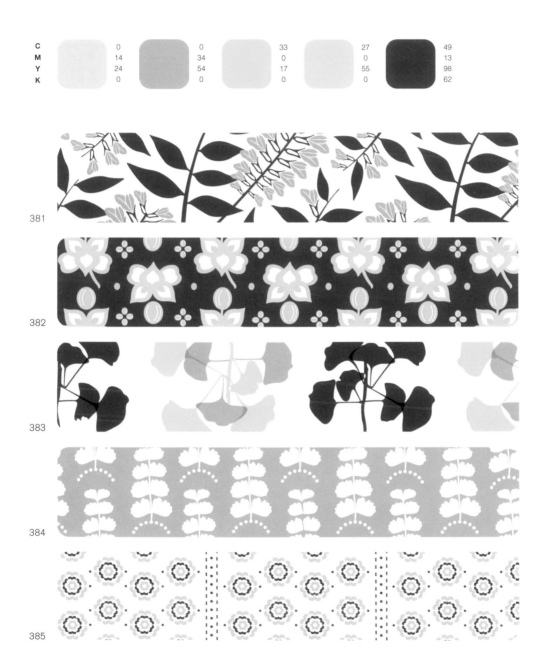

381

382

383

384

385

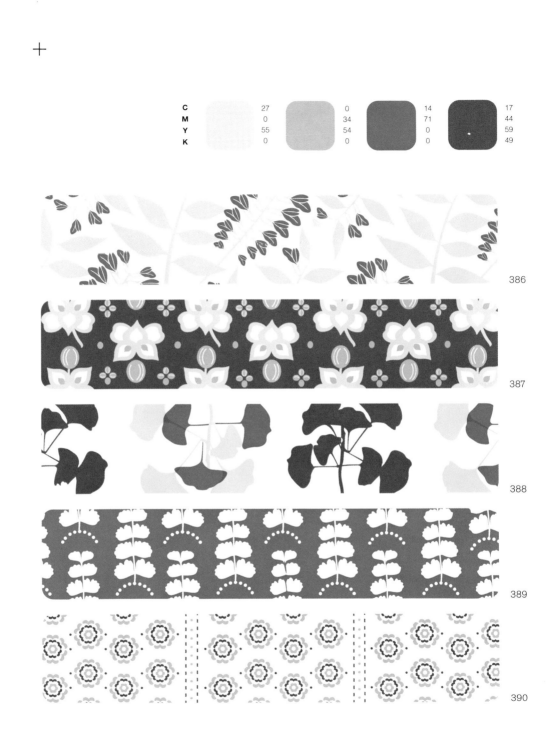

C	27		0		14		17
M	0		34		71		44
Y	55		54		0		59
K	0		0		0		49

386

387

388

389

390

C	3		47		52		49
M	2		0		6		13
Y	62		94		79		98
K	5		0		25		62

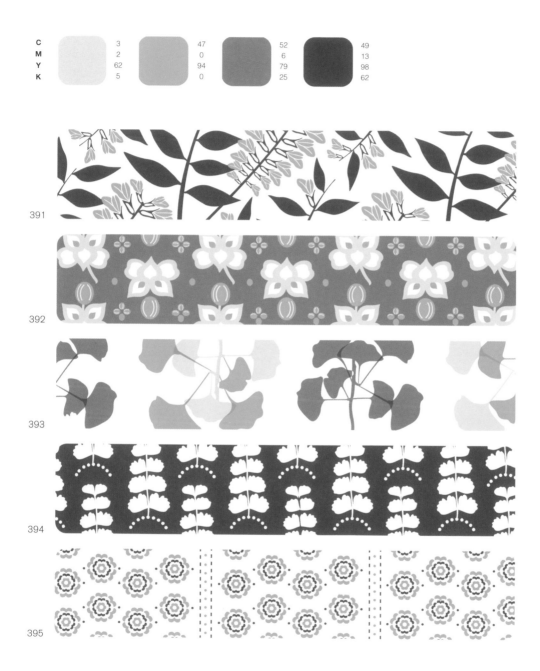

391

392

393

394

395

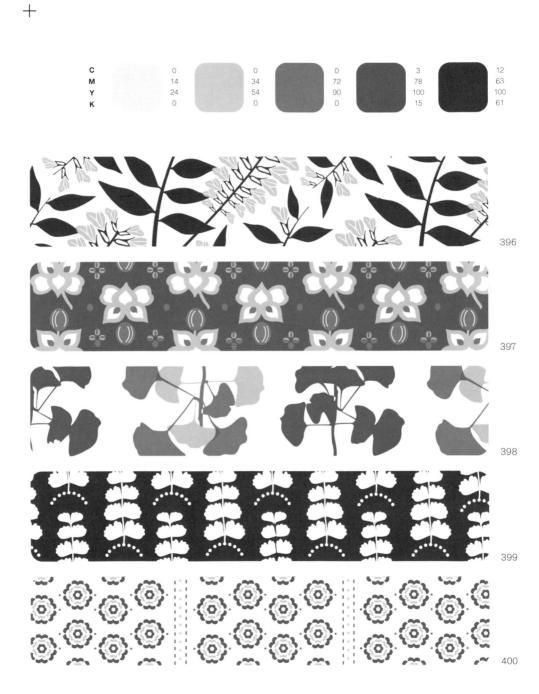

C	0	0	0	3	12
M	14	34	72	78	63
Y	24	54	90	100	100
K	0	0	0	15	61

396

397

398

399

400

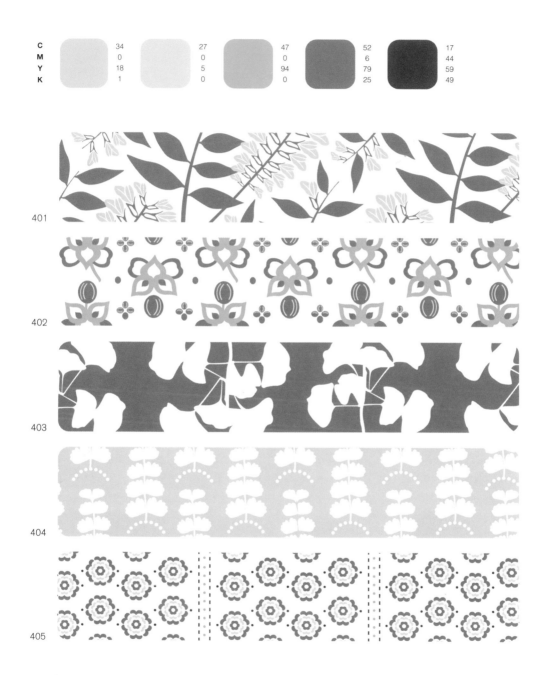

C	34		27		47		52		17
M	0		0		0		6		44
Y	18		5		94		79		59
K	1		0		0		25		49

401

402

403

404

405

C	0		0		14		43
M	34		14		71		90
Y	54		24		0		0
K	0		0		0		0

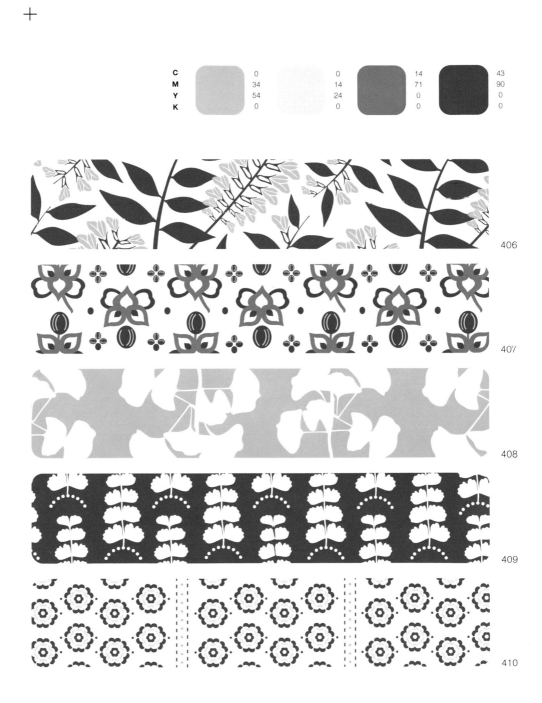

406

407

408

409

410

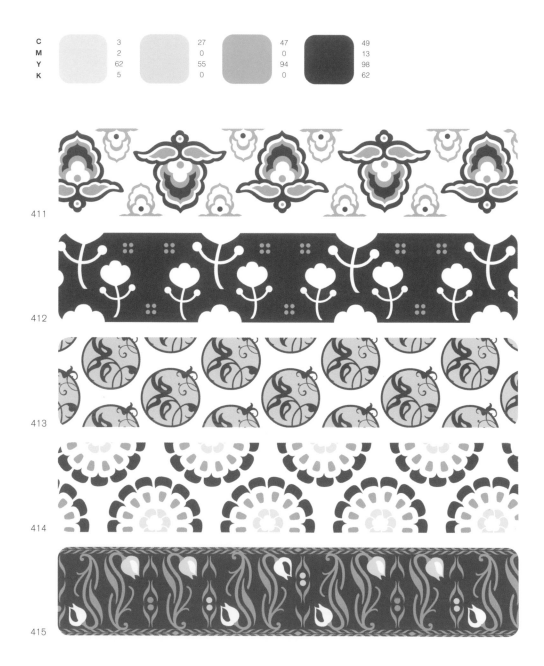

C	3	27	47	49
M	2	0	0	13
Y	62	55	94	98
K	5	0	0	62

411

412

413

414

415

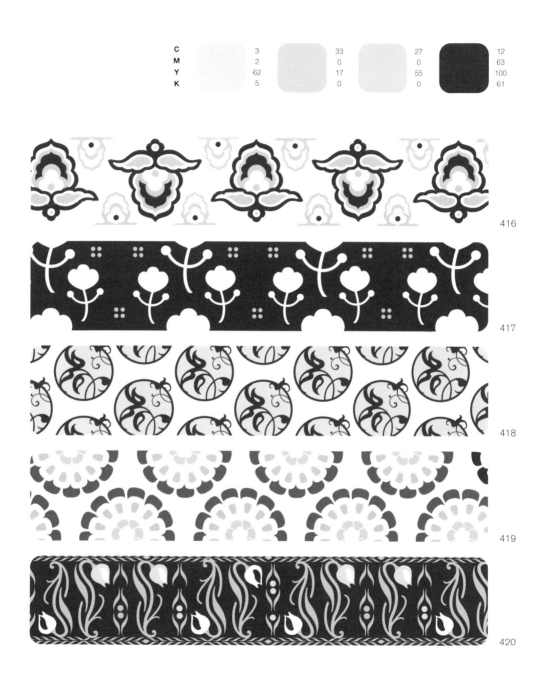

C		3		33		27		12
M		2		0		0		63
Y		62		17		55		100
K		5		0		0		61

416

417

418

419

420

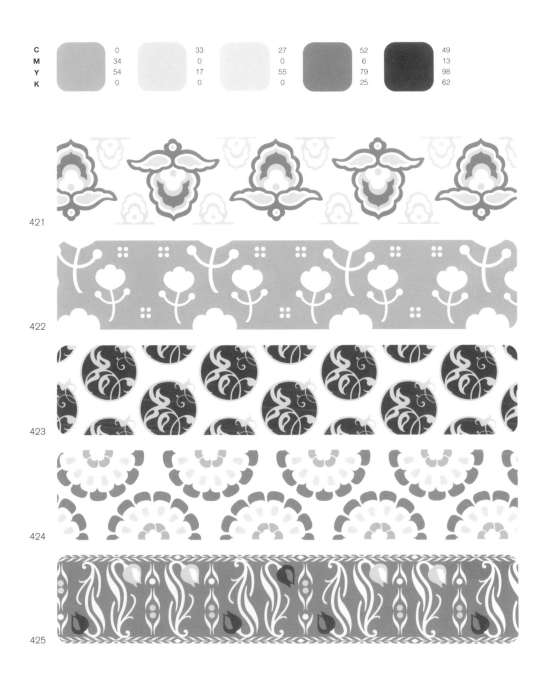

C	0	33	27	52	49
M	34	0	0	6	13
Y	54	17	55	79	98
K	0	0	0	25	62

421

422

423

424

425

C		0		0		33		0		3
M		14		34		0		72		78
Y		24		54		17		90		100
K		0		0		0		0		15

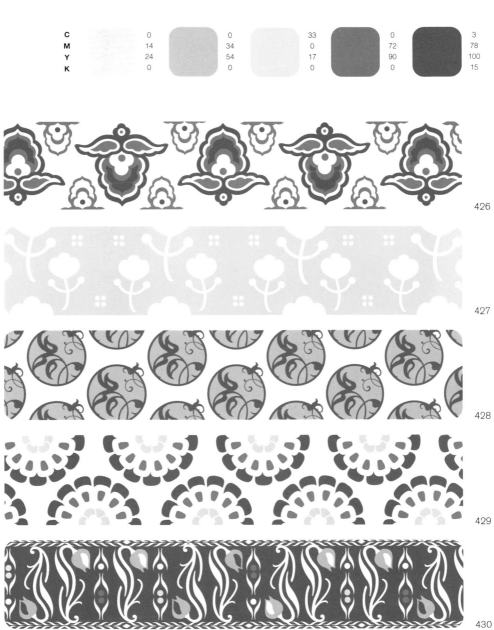

426

427

428

429

430

C	27		47		0		17
M	0		0		34		44
Y	55		94		54		59
K	0		0		0		49

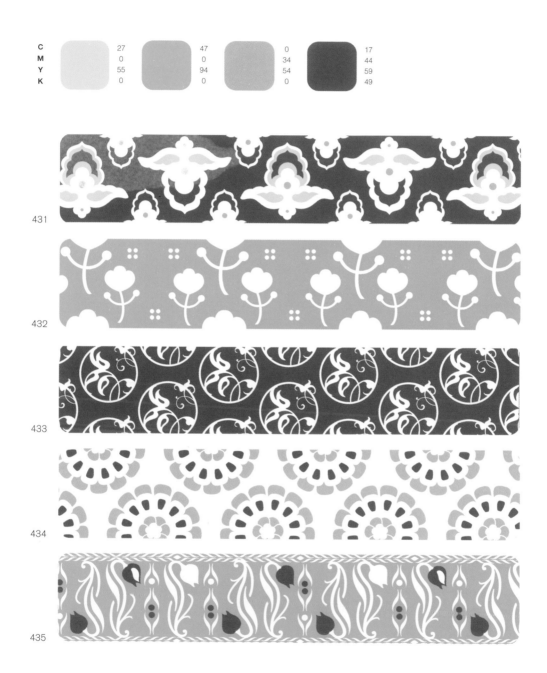

431

432

433

434

435

C	0		0		43		17
M	14		34		90		44
Y	24		54		0		59
K	0		0		0		49

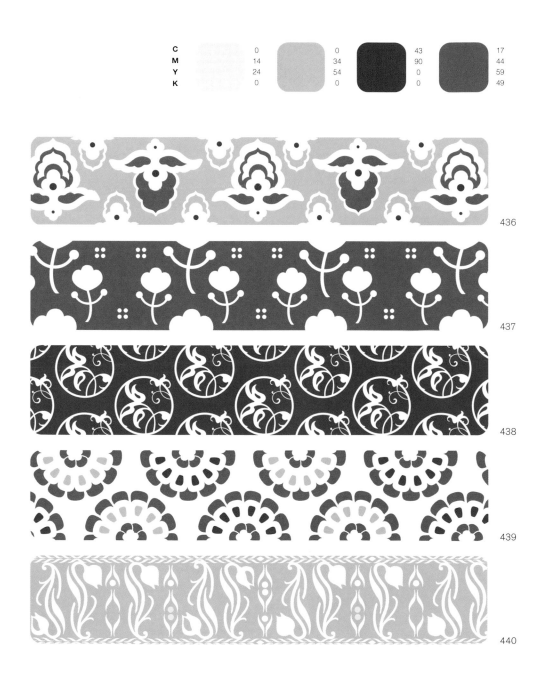

436

437

438

439

440

C	33		0		17		12
M	0		34		44		63
Y	17		54		59		100
K	0		0		49		61

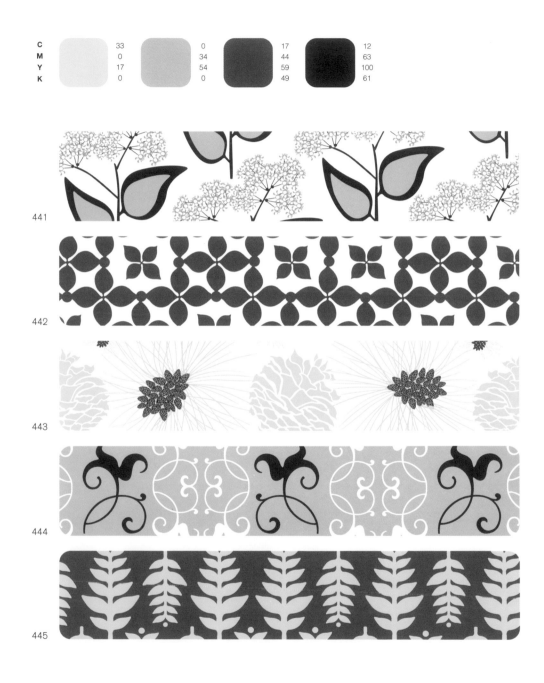

441

442

443

444

445

C		33		27		47		52		49
M		0		0		0		6		13
Y		17		55		94		79		98
K		0		0		0		25		62

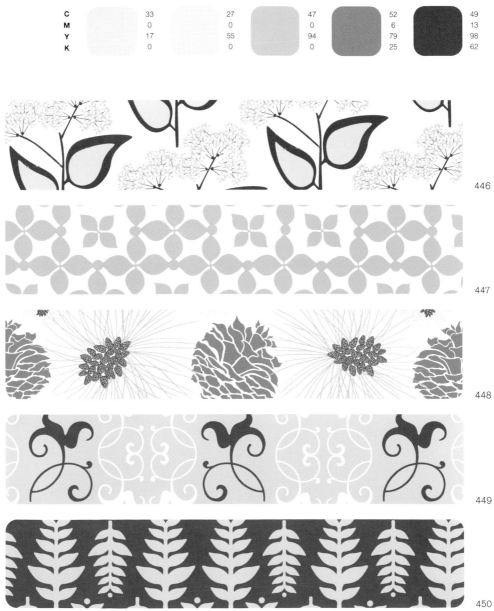

446

447

448

449

450

C		0		3		47		17
M		13		2		0		44
Y		78		62		94		59
K		0		5		0		49

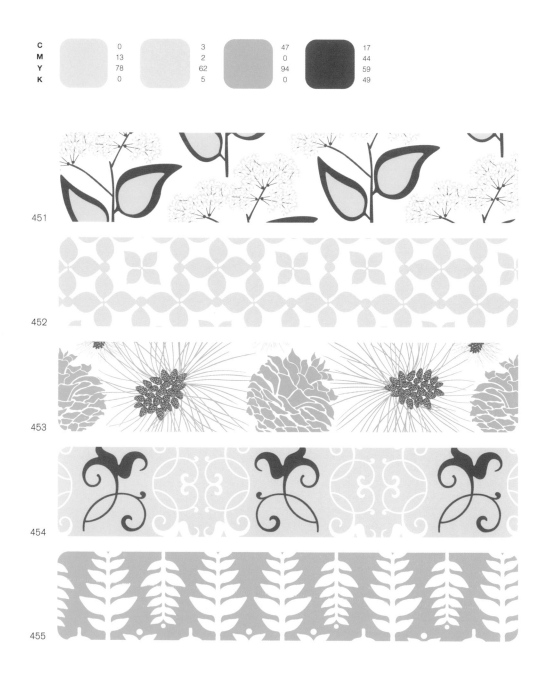

451

452

453

454

455

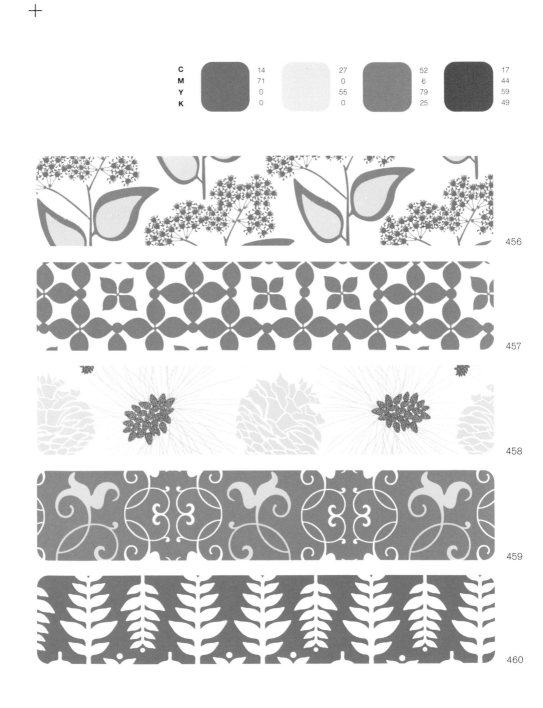

C	14		27		52		17
M	71		0		6		44
Y	0		55		79		59
K	0		0		25		49

456

457

458

459

460

C	3		0		47		52
M	2		72		0		6
Y	62		90		94		79
K	5		0		0		25

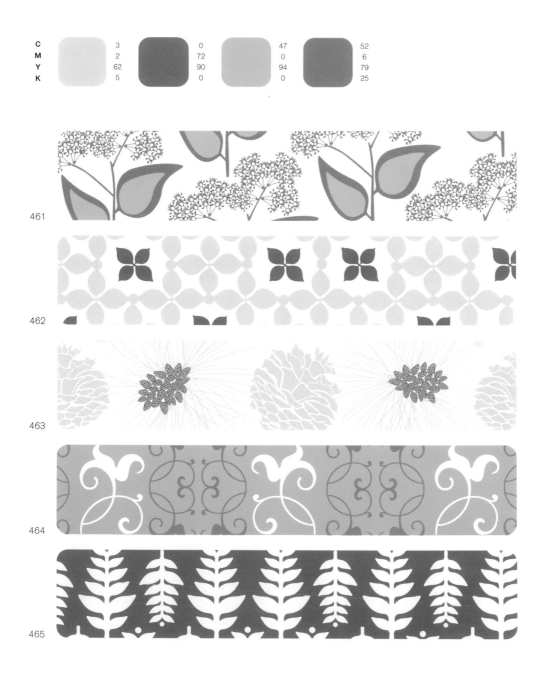

461

462

463

464

465

C	0		33		14		43
M	14		0		71		90
Y	24		17		0		0
K	0		0		0		0

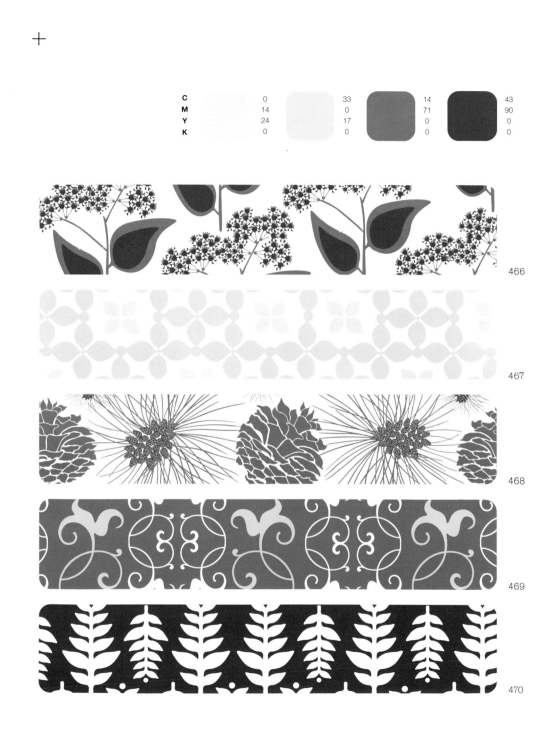

466

467

468

469

470

C		0		0		0		3		17
M		14		34		72		78		44
Y		24		54		90		100		59
K		0		0		0		15		49

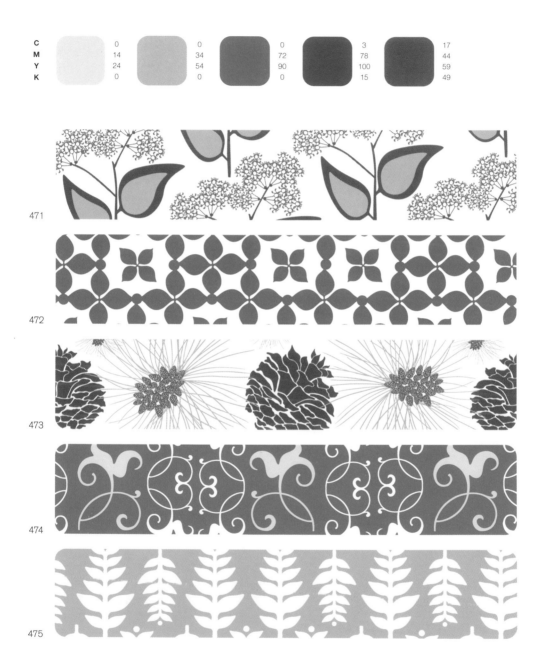

471

472

473

474

475

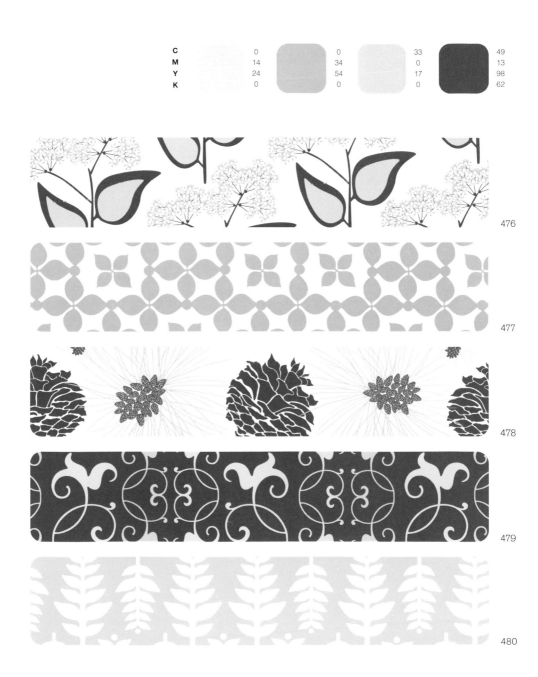

C	0		0		33		49
M	14		34		0		13
Y	24		54		17		98
K	0		0		0		62

476

477

478

479

480

From Marrakech to Monte Carlo, destinations around the world evoke their culture passionately through the use of colors, designs, and artwork. This series of patterns finds inspiration from the places we long to explore. Dreamy hues of aqua gleam like the intricate tiles of Seville, bold colors resonate like the timeless bazaars of Egypt, and geometric patterns echo Asian style and symmetry.

Global Maven

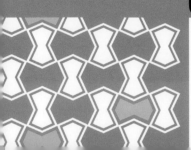

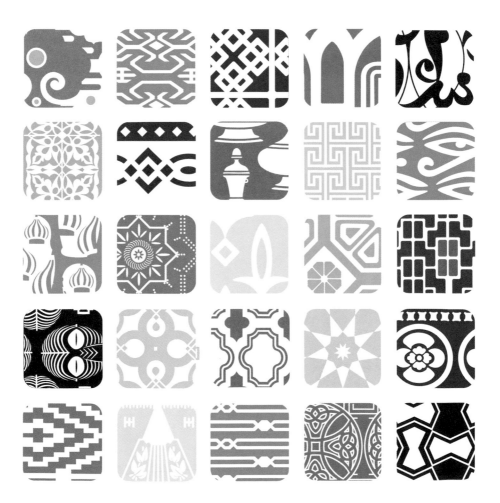

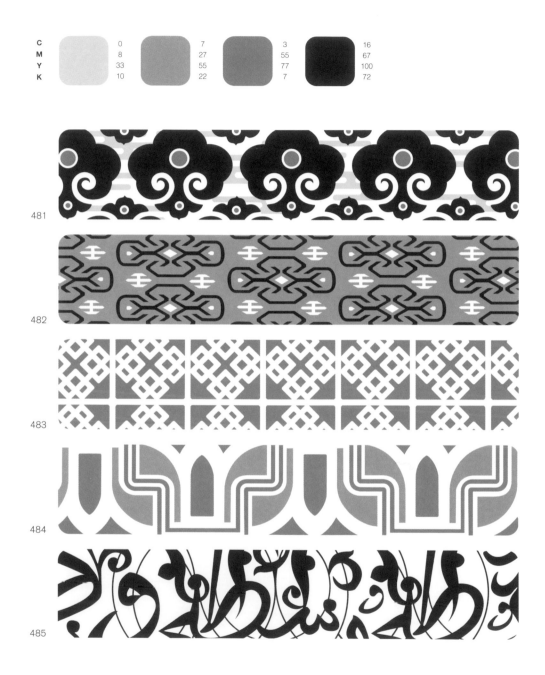

C	0		7		3		16
M	8		27		55		67
Y	33		55		77		100
K	10		22		7		72

481

482

483

484

485

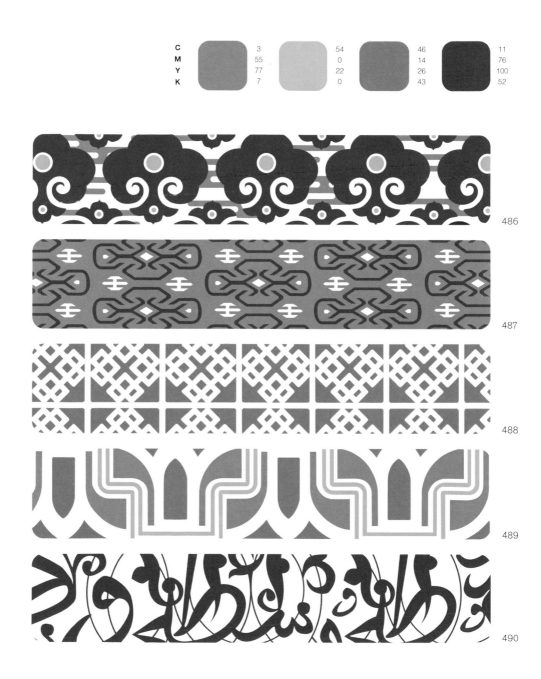

C	3	54	46	11
M	55	0	14	76
Y	77	22	26	100
K	7	0	43	52

486

487

488

489

490

C	0	0	12	13
M	8	31	8	23
Y	33	43	35	67
K	10	2	22	38

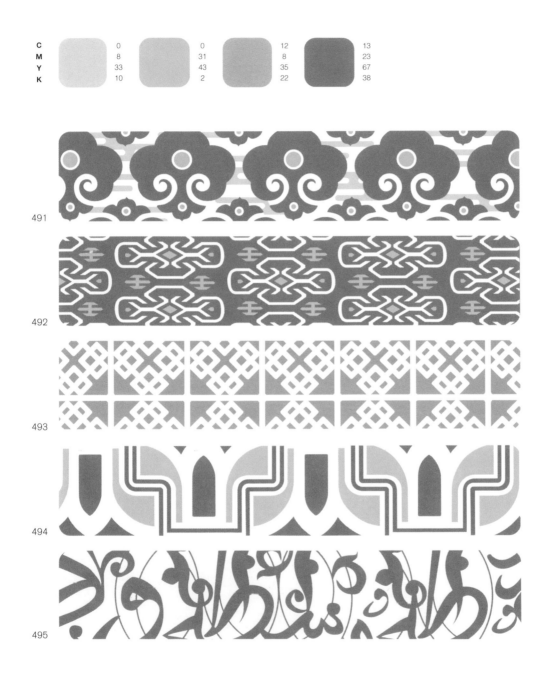

491

492

493

494

495

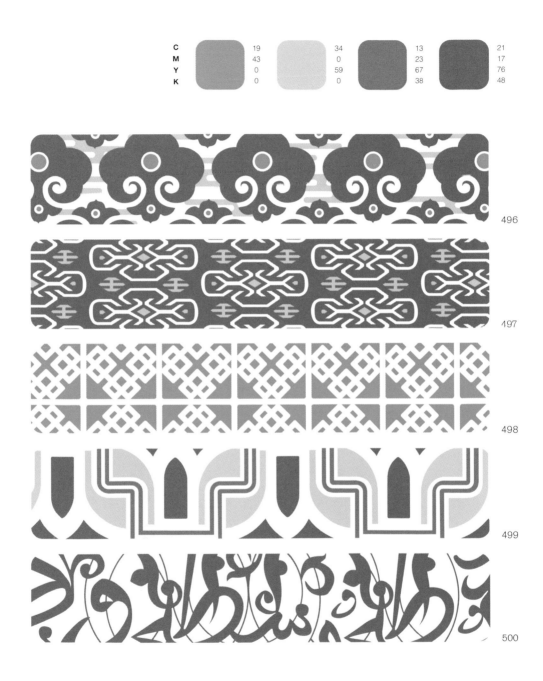

C	19		34		13		21
M	43		0		23		17
Y	0		59		67		76
K	0		0		38		48

496

497

498

499

500

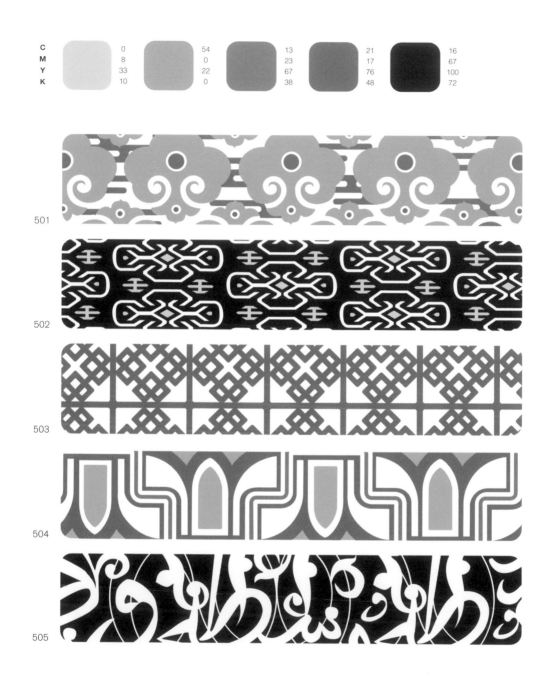

C	0	54	13	21	16
M	8	0	23	17	67
Y	33	22	67	76	100
K	10	0	38	48	72

501

502

503

504

505

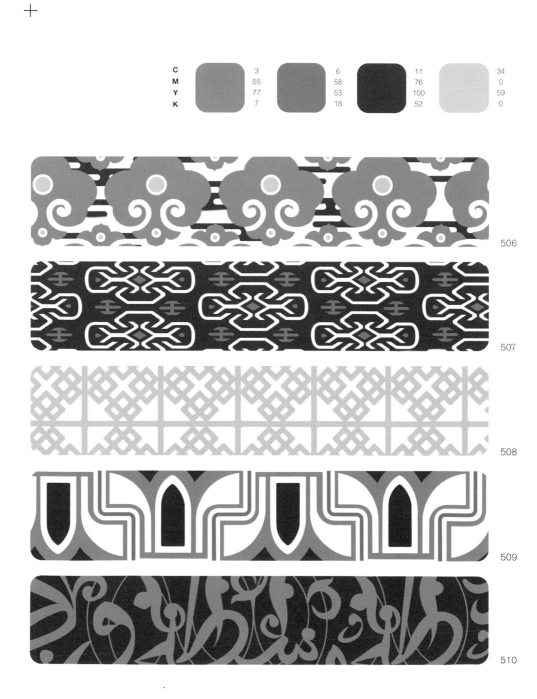

C	3		6		11		34
M	55		58		76		0
Y	77		53		100		59
K	7		18		52		0

506

507

508

509

510

C		0		7		3		16
M		8		27		55		67
Y		33		55		77		100
K		10		22		7		72

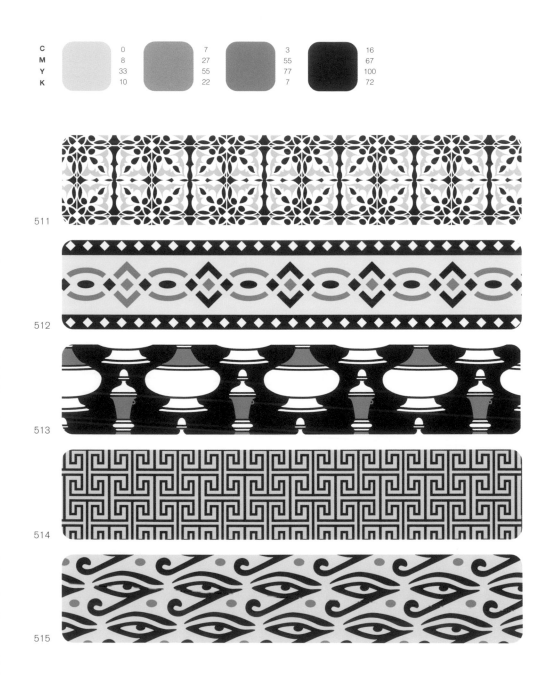

511

512

513

514

515

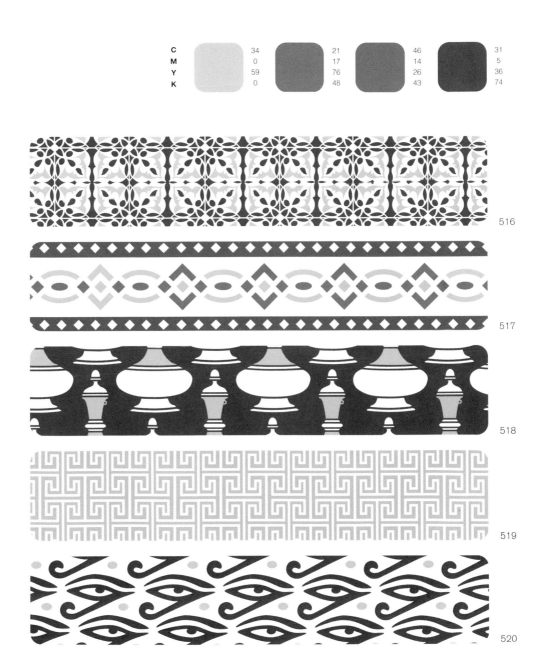

C	34		21		46		31
M	0		17		14		5
Y	59		76		26		36
K	0		48		43		74

516

517

518

519

520

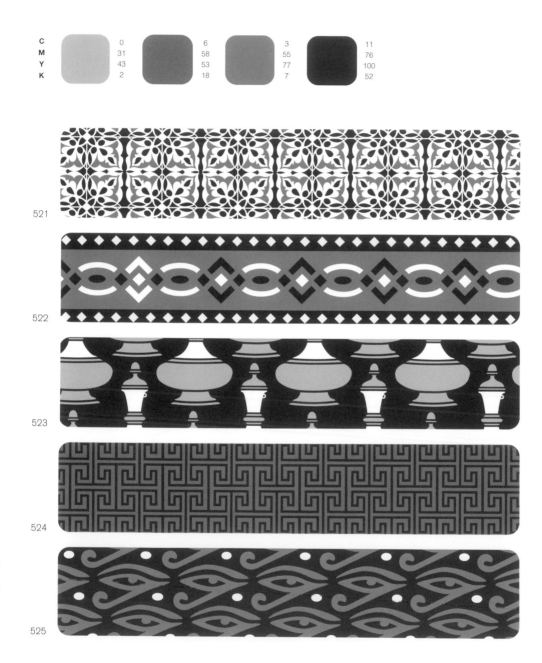

C		0		6		3		11
M		31		58		55		76
Y		43		53		77		100
K		2		18		7		52

521

522

523

524

525

C		54		34		21		16
M		0		0		17		67
Y		22		59		76		100
K		0		0		48		72

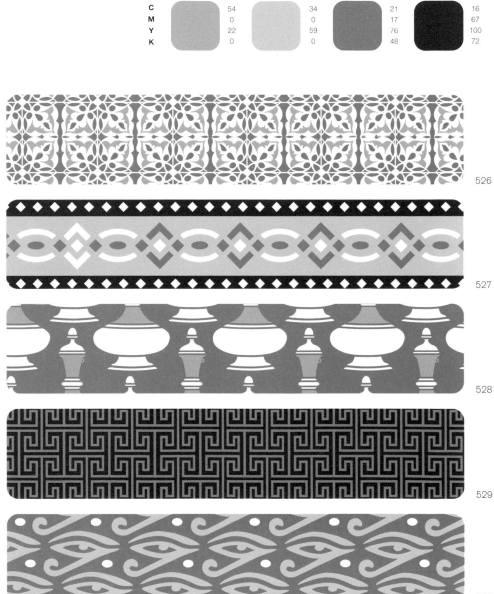

526

527

528

529

530

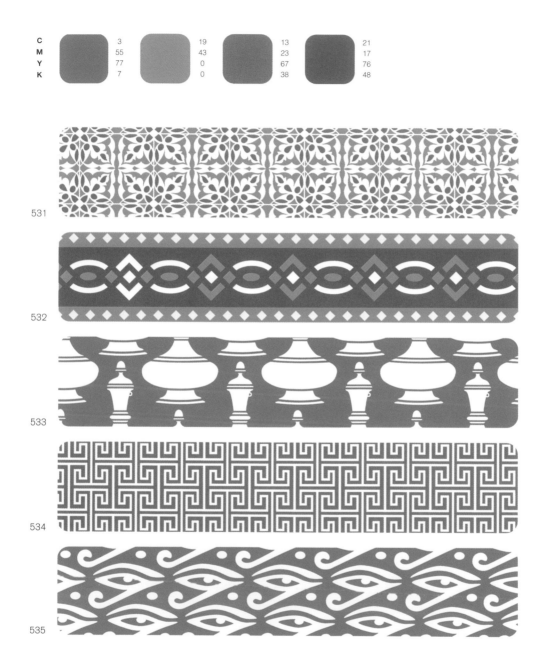

C	3	19	13	21
M	55	43	23	17
Y	77	0	67	76
K	7	0	38	48

531

532

533

534

535

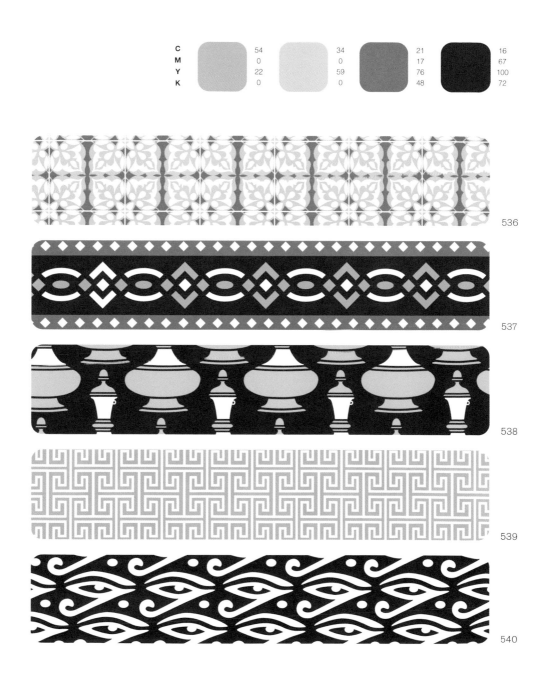

C	54	34	21	16
M	0	0	17	67
Y	22	59	76	100
K	0	0	48	72

536

537

538

539

540

C	0		0		21		16
M	8		31		17		67
Y	33		43		76		100
K	10		2		48		72

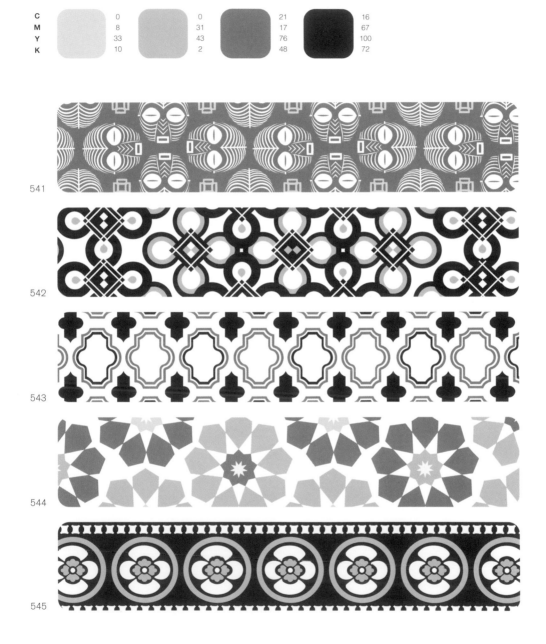

541

542

543

544

545

C	3		11		7		16
M	55		76		27		67
Y	77		100		55		100
K	7		52		22		72

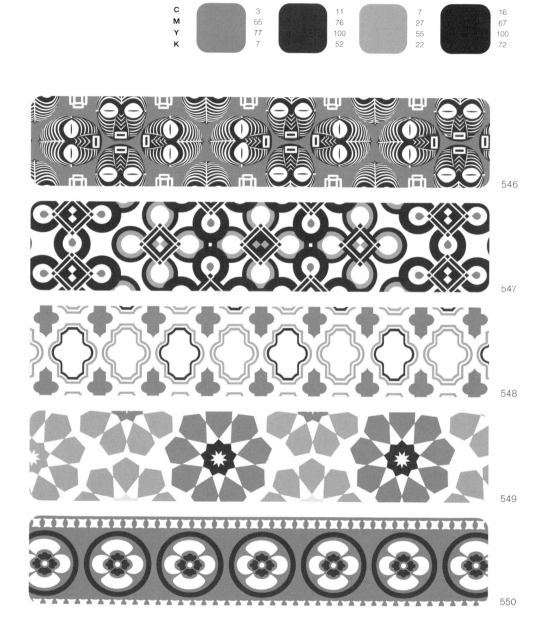

546

547

548

549

550

C			19		34		12		16
M			43		0		8		67
Y			0		59		35		100
K			0		0		22		72

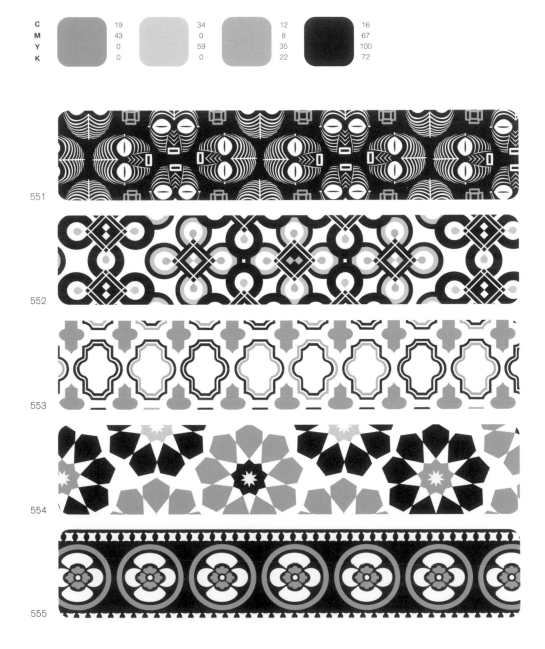

551

552

553

554

555

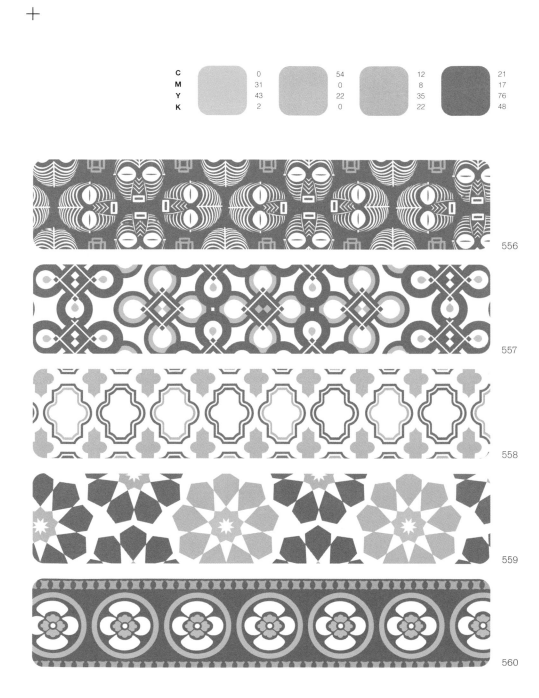

C	0		54		12		21
M	31		0		8		17
Y	43		22		35		76
K	2		0		22		48

556

557

558

559

560

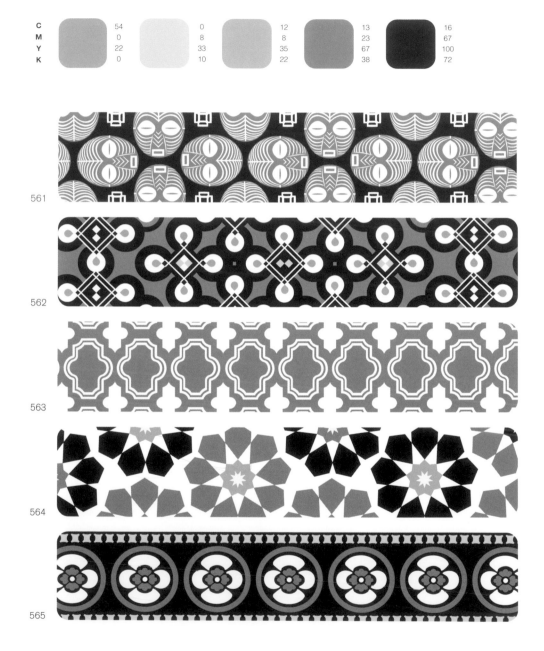

C	54	0	12	13	16
M	0	8	8	23	67
Y	22	33	35	67	100
K	0	10	22	38	72

561

562

563

564

565

C		0		12		6		11
M		8		8		58		76
Y		33		35		53		100
K		10		22		18		52

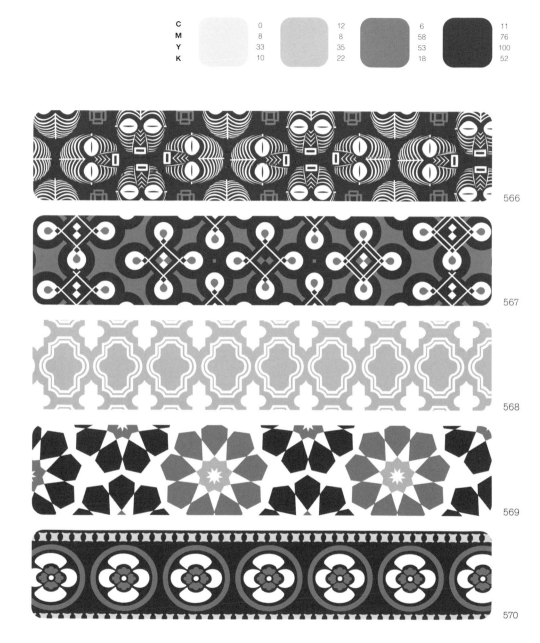

566

567

568

569

570

C	3		12		34		21
M	55		8		0		17
Y	77		35		59		76
K	7		22		0		48

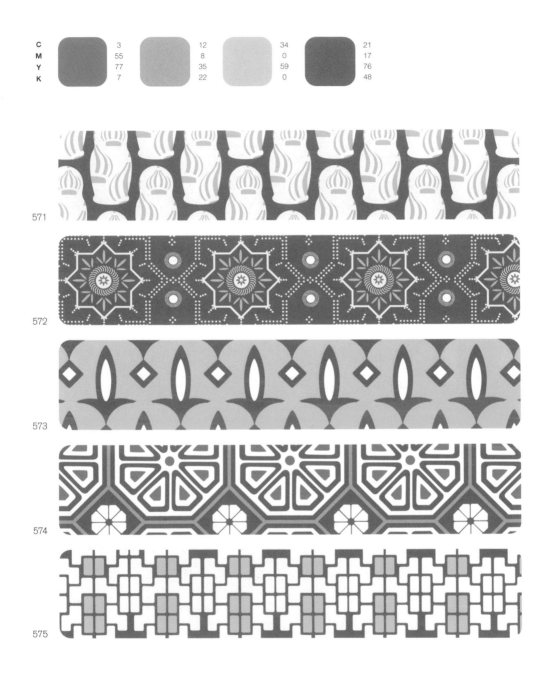

571

572

573

574

575

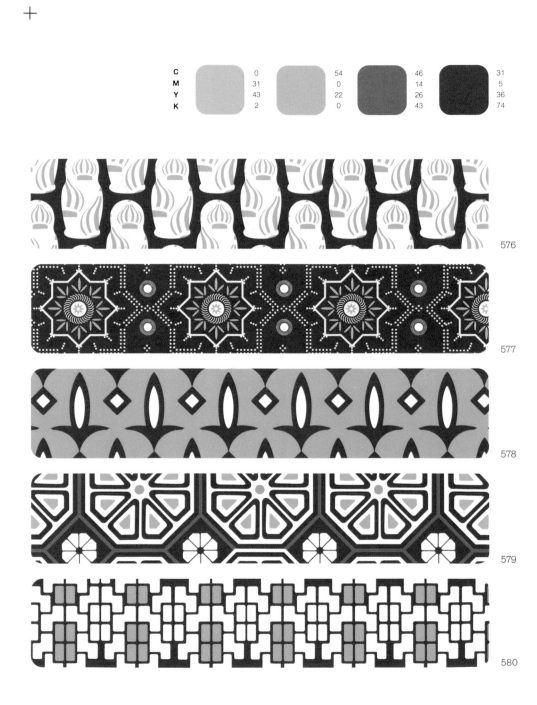

C	0	54	46	31
M	31	0	14	5
Y	43	22	26	36
K	2	0	43	74

576

577

578

579

580

C	0		19		12		16
M	8		43		8		67
Y	33		0		35		100
K	10		0		22		72

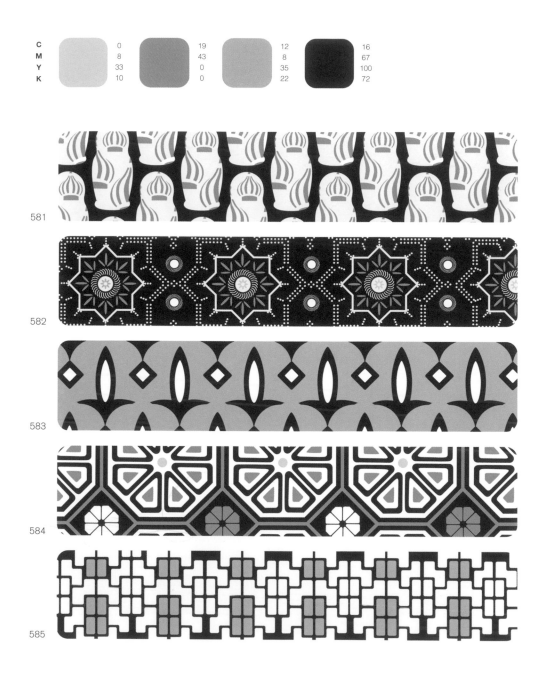

581

582

583

584

585

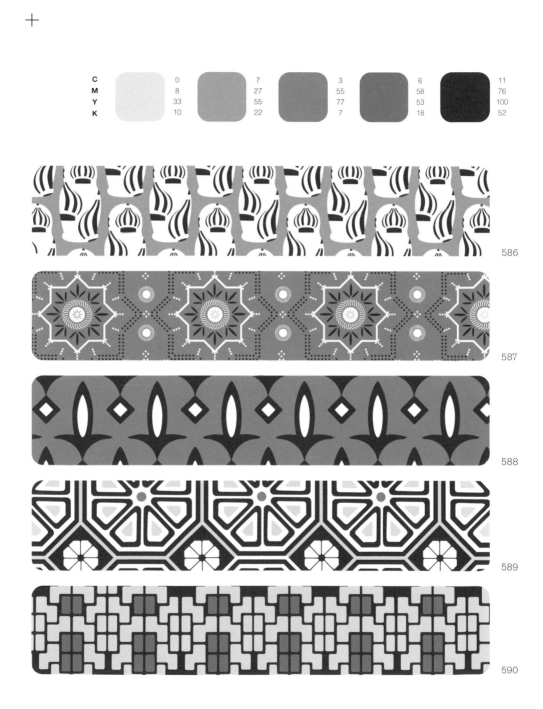

C	0	7	3	6	11
M	8	27	55	58	76
Y	33	55	77	53	100
K	10	22	7	18	52

586

587

588

589

590

C		7		0		3		16		21
M		27		31		55		67		17
Y		55		43		77		100		76
K		22		2		7		72		48

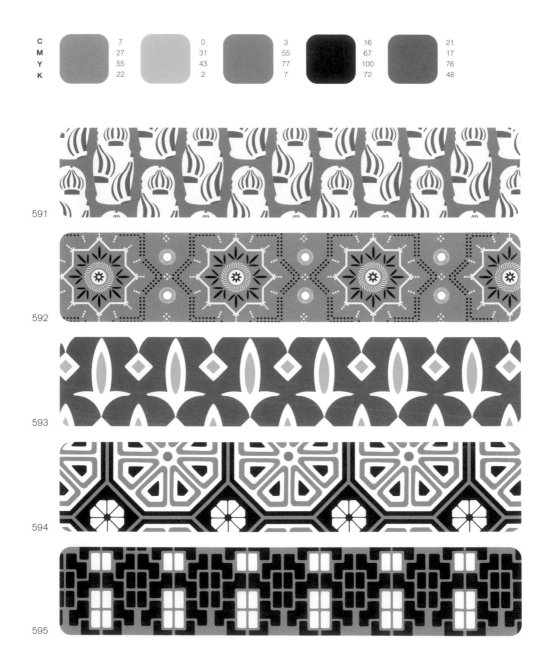

591

592

593

594

595

C	34		21		6		31
M	0		17		58		5
Y	59		76		53		36
K	0		48		18		74

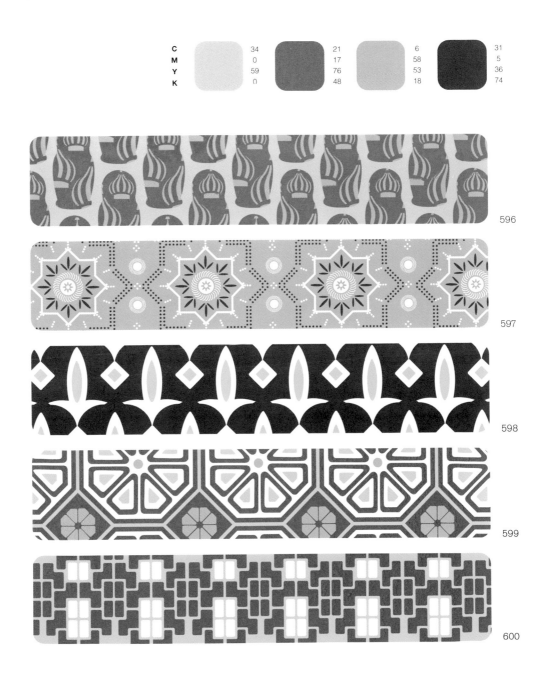

596

597

598

599

600

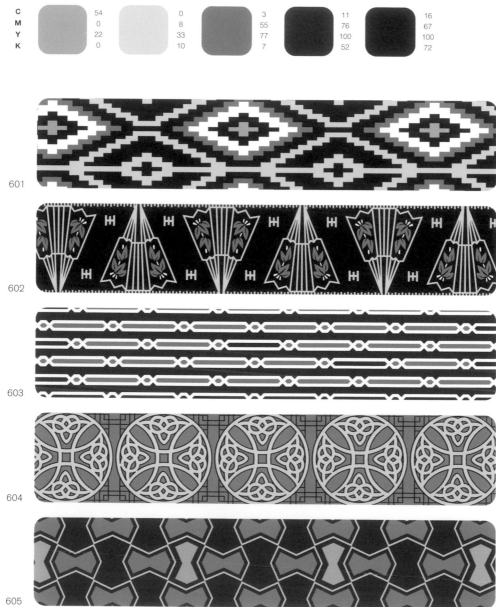

C	54	0	3	11	16
M	0	8	55	76	67
Y	22	33	77	100	100
K	0	10	7	52	72

601

602

603

604

605

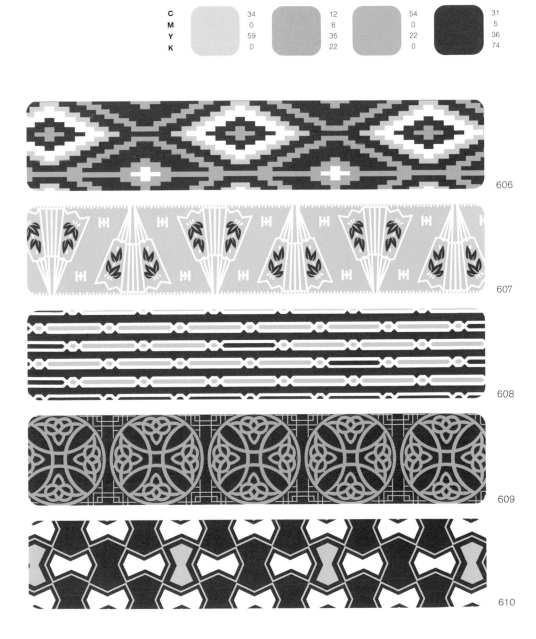

C	34		12		54		31
M	0		8		0		5
Y	59		35		22		36
K	0		22		0		74

606

607

608

609

610

C	0		0		12		13		16
M	31		8		8		23		67
Y	43		33		35		67		100
K	2		10		22		38		72

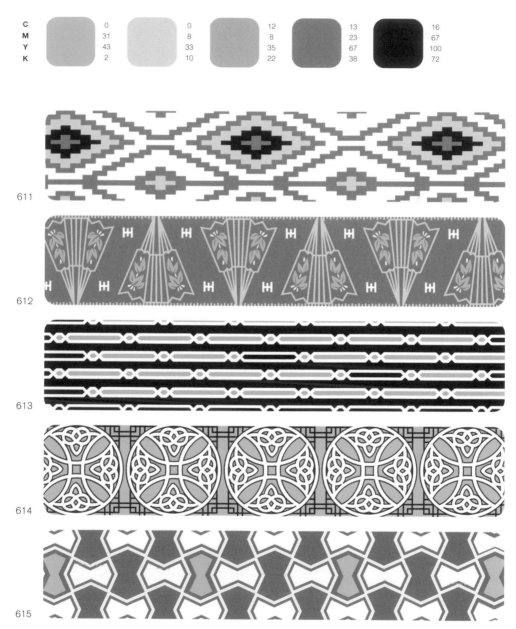

611

612

613

614

615

C	19		12		21		16
M	43		8		17		67
Y	0		35		76		100
K	0		22		48		72

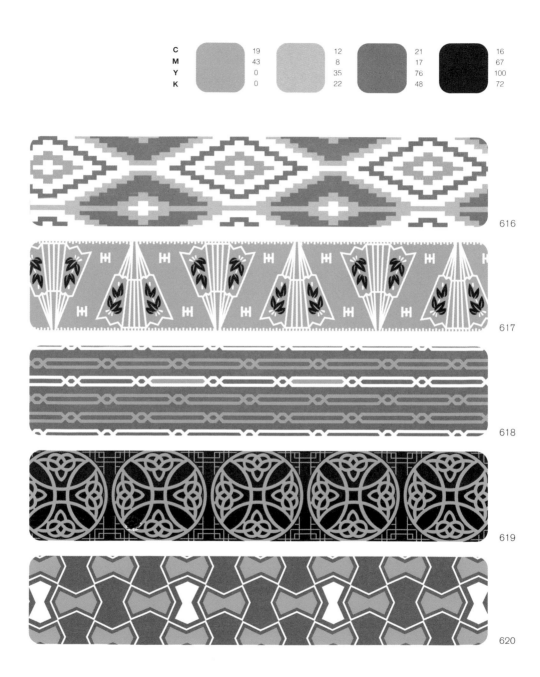

616

617

618

619

620

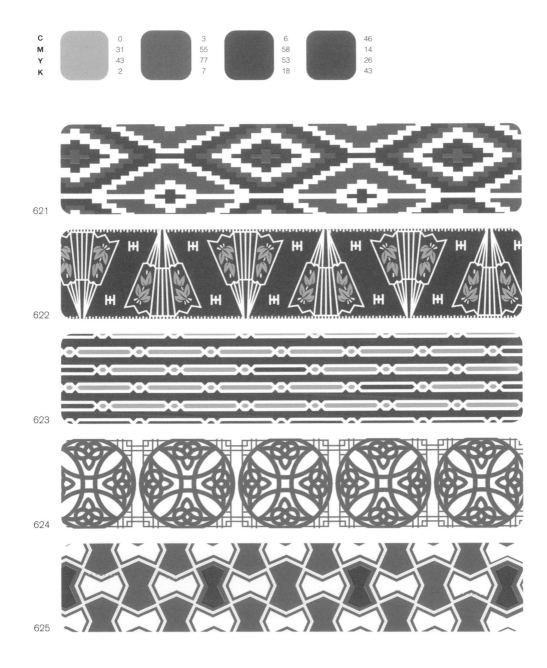

C	0	3	6	46
M	31	55	58	14
Y	43	77	53	26
K	2	7	18	43

621

622

623

624

625

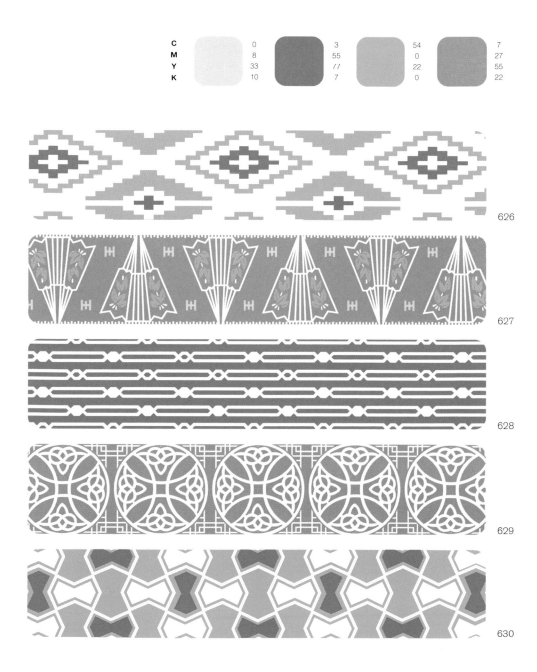

C	0		3		54		7
M	8		55		0		27
Y	33		77		22		55
K	10		7		0		22

626

627

628

629

630

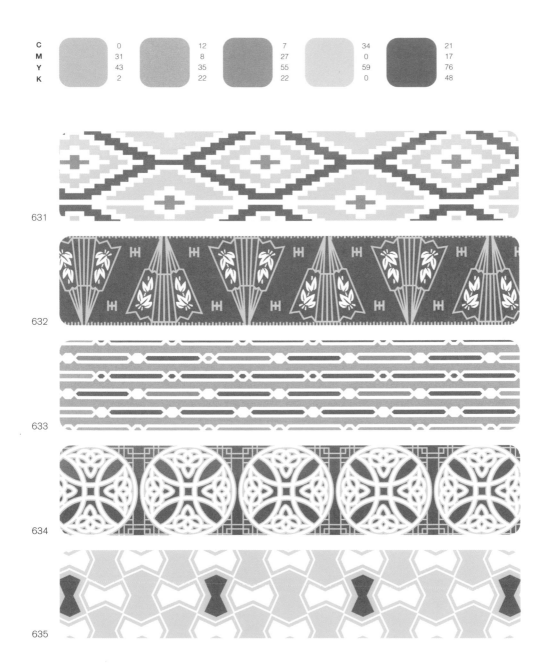

C	0	12	7	34	21
M	31	8	27	0	17
Y	43	35	55	59	76
K	2	22	22	0	48

631

632

633

634

635

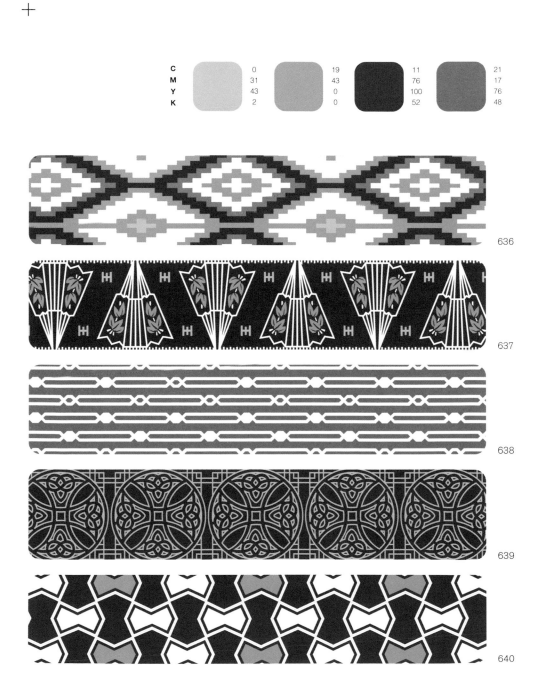

C	0	19	11	21
M	31	43	76	17
Y	43	0	100	76
K	2	0	52	48

636

637

638

639

640

With bold geometric shapes and dramatic color combinations, these pages hum with action. The use of rich, expressive colors, juxtaposed with strong designs, works wonderfully here. Turn the pages through Pop Impresario and find a surprising mix of mesmerizing patterns and palettes. Pop's playfulness is balanced thoughtfully with colors that harmonize carefully with each design.

Pop Impresario

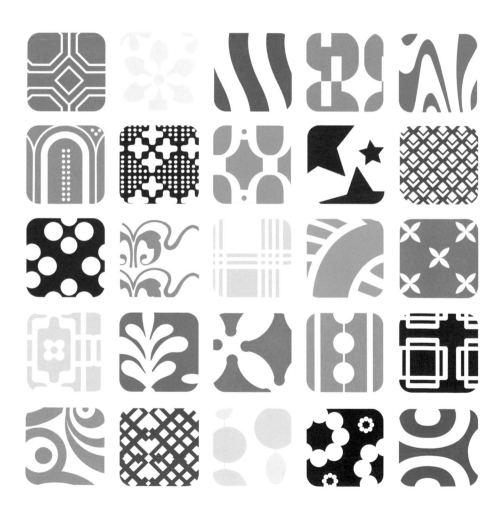

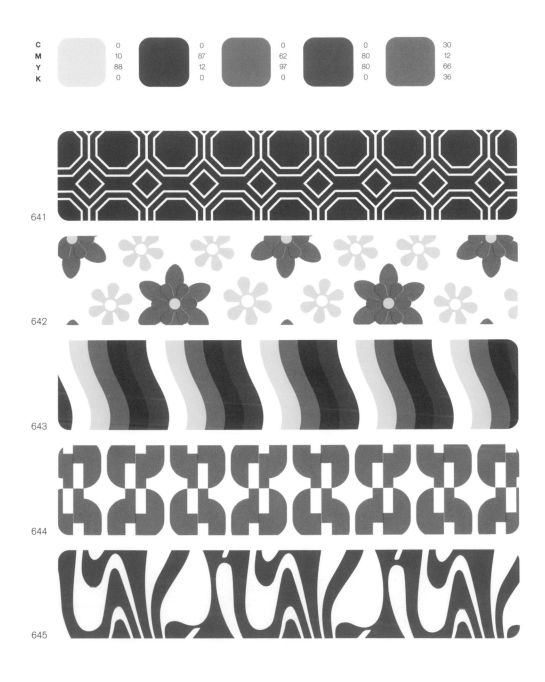

C	0		0		0		0		30
M	10		87		62		80		12
Y	88		12		97		80		66
K	0		0		0		0		36

641

642

643

644

645

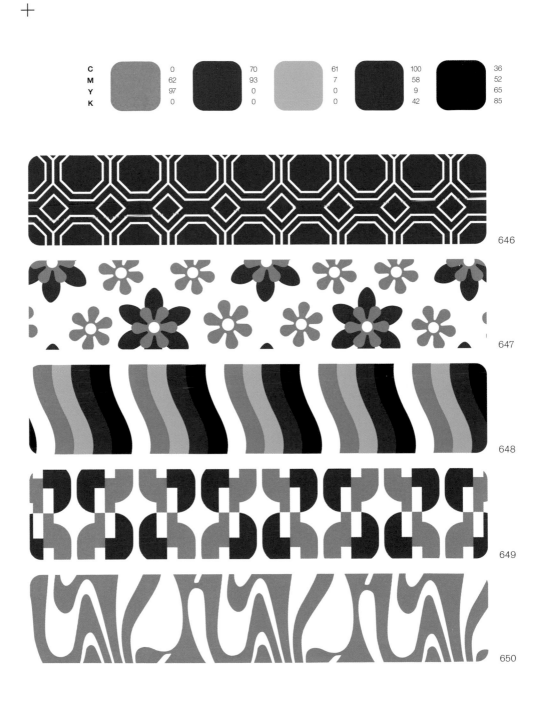

C	0		70		61		100		36
M	62		93		7		58		52
Y	97		0		0		9		65
K	0		0		0		42		85

646

647

648

649

650

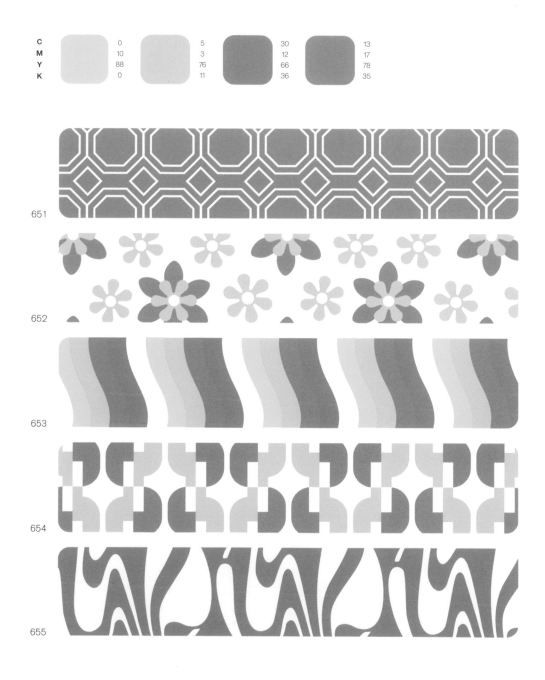

C	0	5	30	13
M	10	3	12	17
Y	88	76	66	78
K	0	11	36	35

651

652

653

654

655

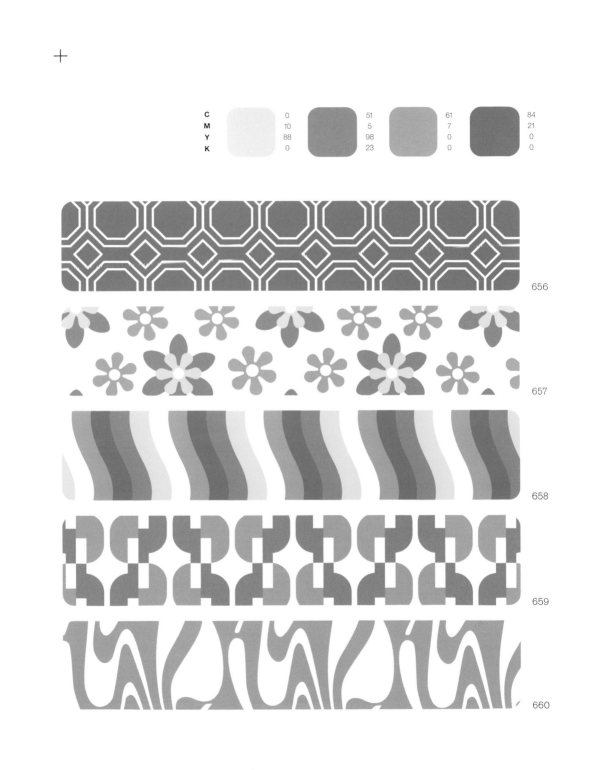

C	0		51		61		84
M	10		5		7		21
Y	88		98		0		0
K	0		23		0		0

656

657

658

659

660

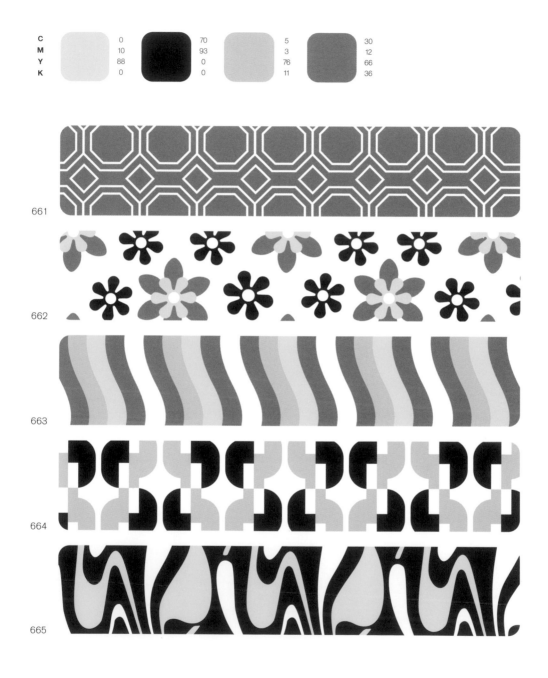

C	0	70	5	30
M	10	93	3	12
Y	88	0	76	66
K	0	0	11	36

661

662

663

664

665

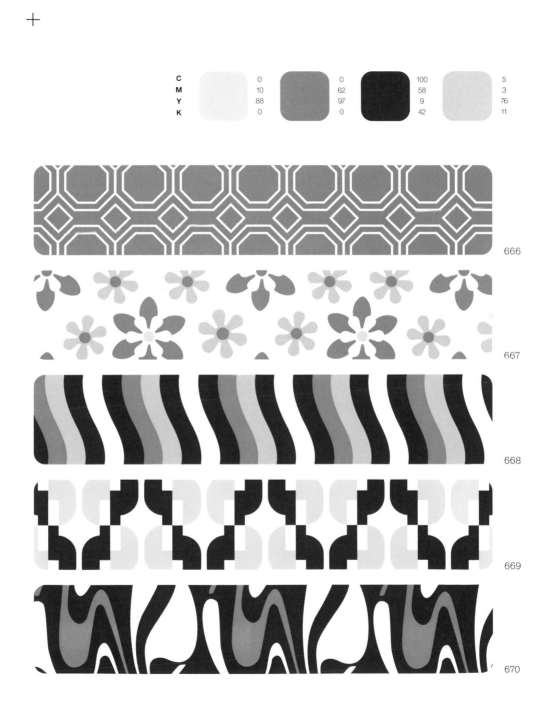

C		0		0		100		5
M		10		62		58		3
Y		88		97		9		76
K		0		0		42		11

666

667

668

669

670

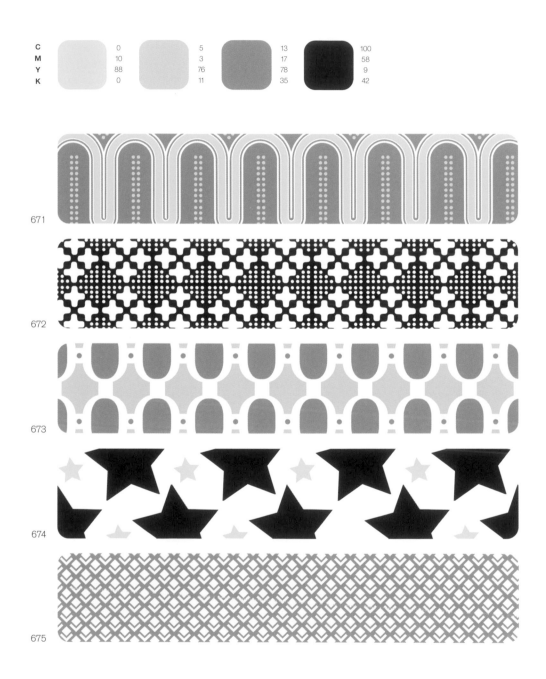

C	0	5	13	100
M	10	3	17	58
Y	88	76	78	9
K	0	11	35	42

671

672

673

674

675

C	51		0		61		100	
M	5		87		7		58	
Y	98		12		0		9	
K	23		0		0		42	

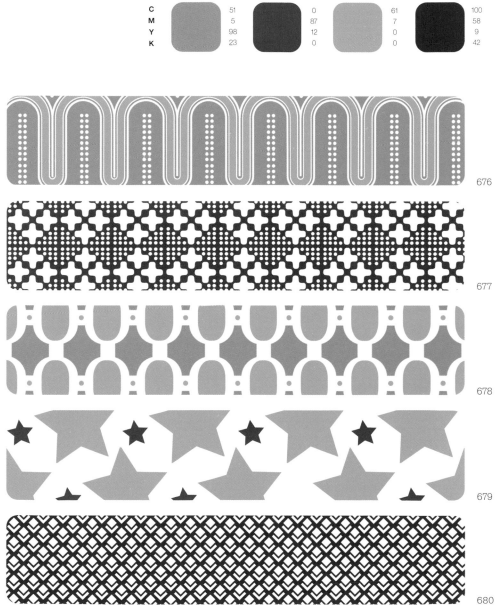

676

677

678

679

680

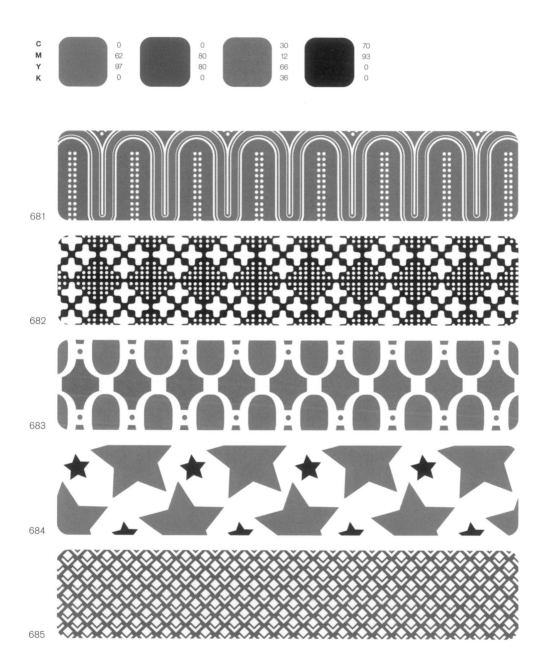

		0		0		30		70
C		0		0		30		70
M		62		80		12		93
Y		97		80		66		0
K		0		0		36		0

681

682

683

684

685

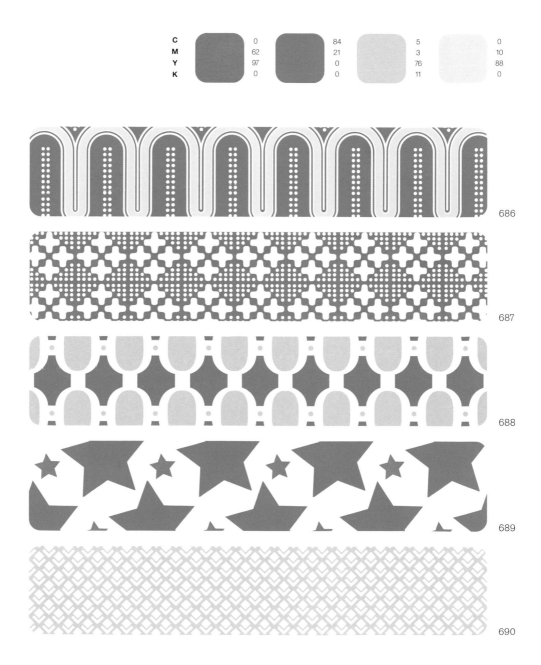

C	0		84		5		0
M	62		21		3		10
Y	97		0		76		88
K	0		0		11		0

686

687

688

689

690

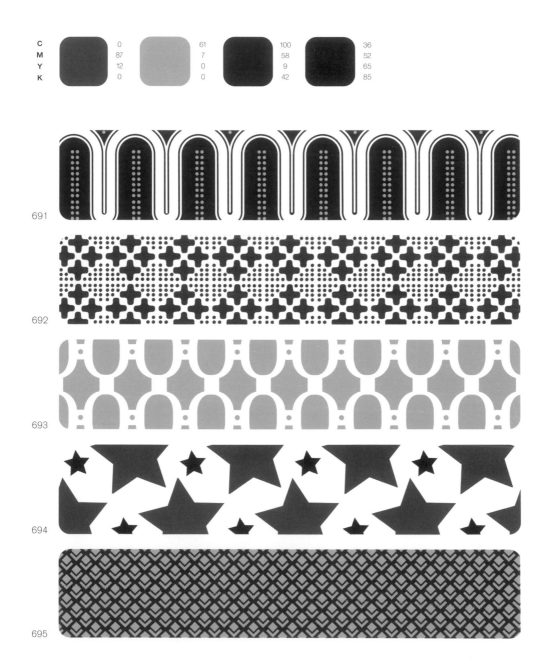

C	0		61		100		36
M	87		7		58		52
Y	12		0		9		65
K	0		0		42		85

691

692

693

694

695

C		0		5		30		0
M		10		3		12		62
Y		88		76		66		97
K		0		11		36		0

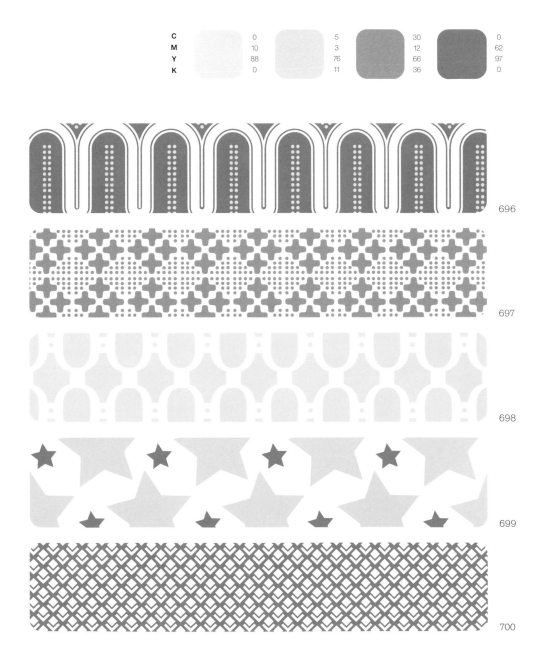

696

697

698

699

700

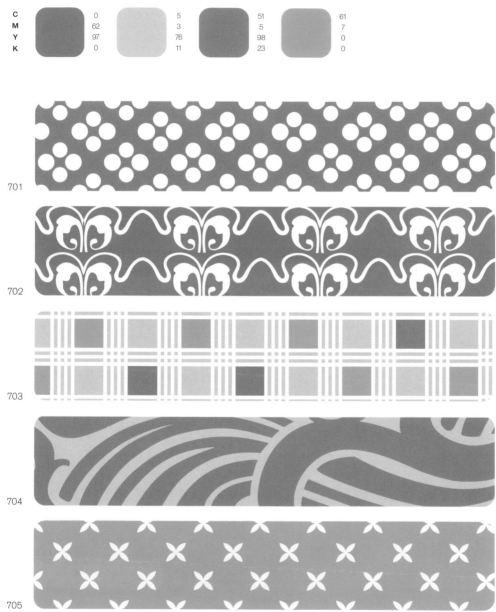

C	0	5	51	61		
M	62	3	5	7		
Y	97	76	98	0		
K	0	11	23	0		

701

702

703

704

705

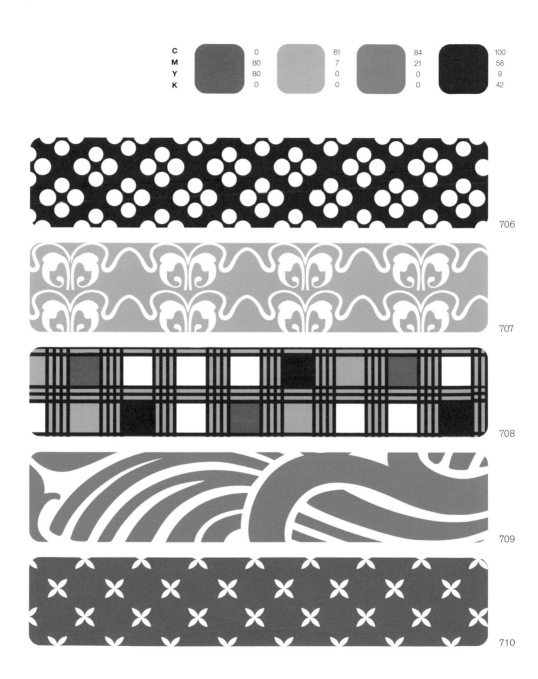

C	0		61		84		100
M	80		7		21		58
Y	80		0		0		9
K	0		0		0		42

706

707

708

709

710

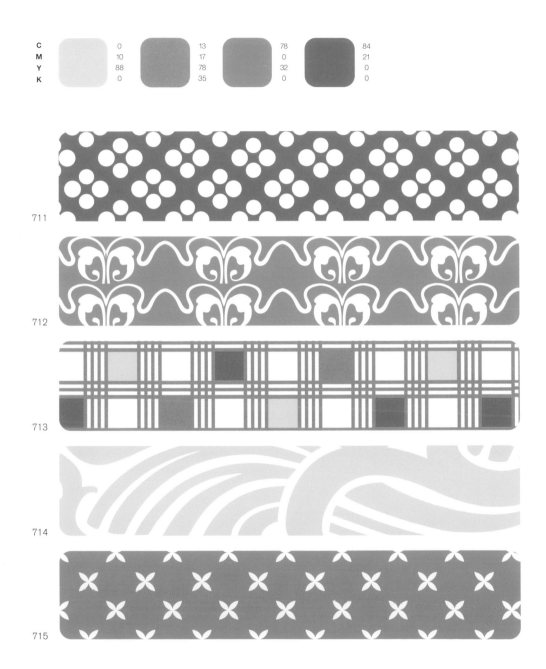

C	0	13	78	84
M	10	17	0	21
Y	88	78	32	0
K	0	35	0	0

711

712

713

714

715

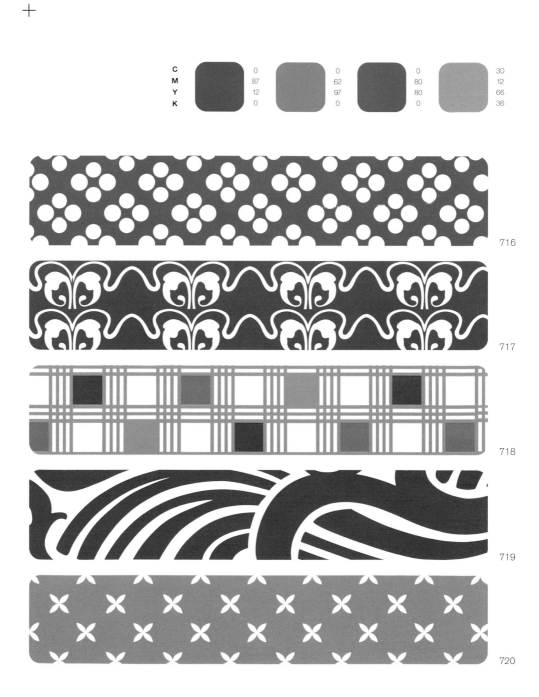

C	0		0		0		30
M	87		62		80		12
Y	12		97		80		66
K	0		0		0		36

716

717

718

719

720

C	0	0	70	100
M	87	62	93	58
Y	12	97	0	9
K	0	0	0	42

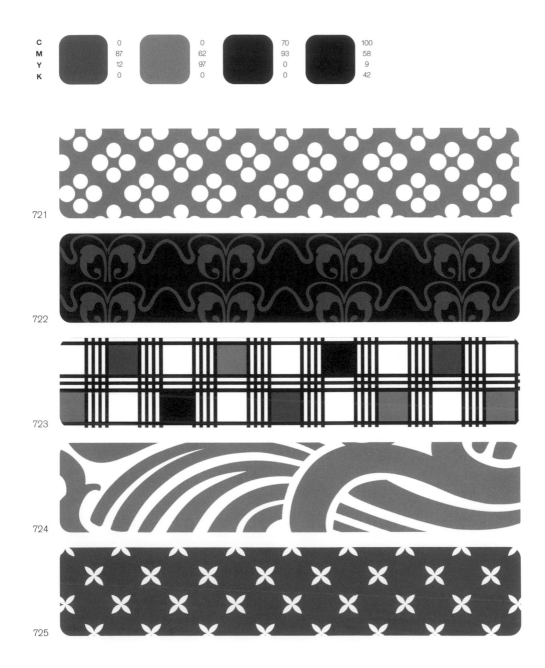

721

722

723

724

725

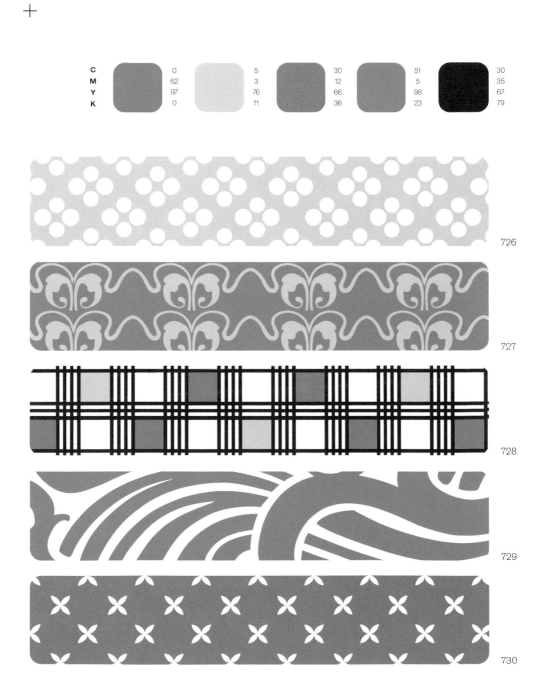

C	0		5		30		51		30
M	62		3		12		5		35
Y	97		76		66		98		62
K	0		11		36		23		79

726

727

728

729

730

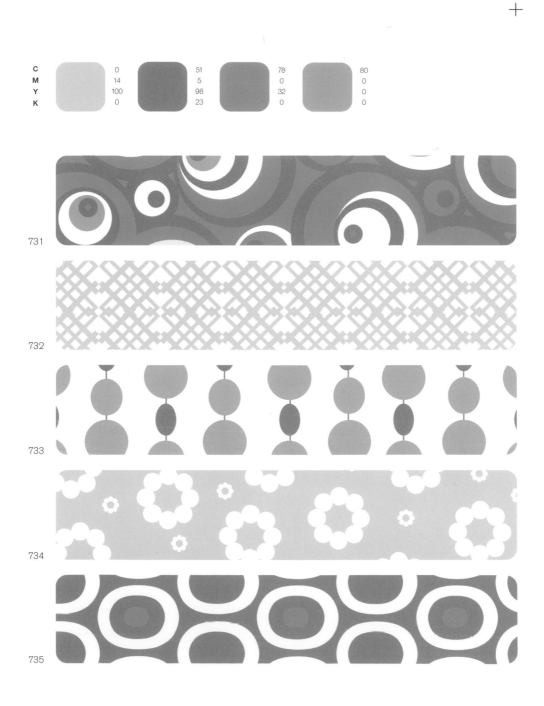

C	0	51	78	80
M	14	5	0	0
Y	100	98	32	0
K	0	23	0	0

731

732

733

734

735

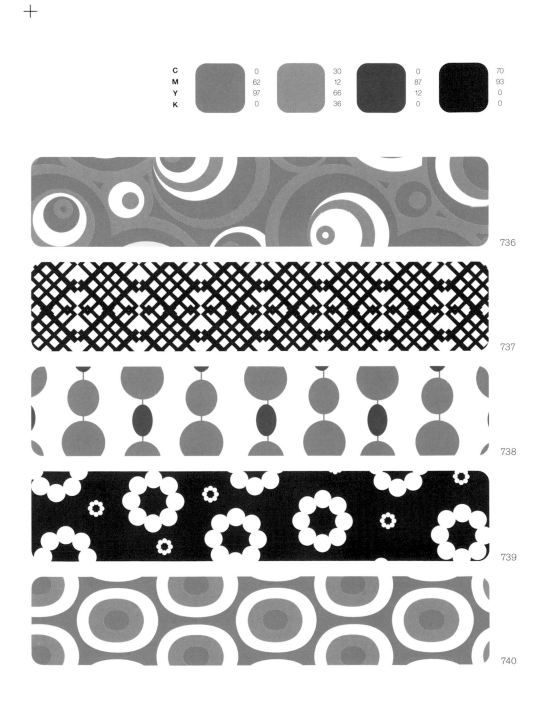

C	0		30		0		70
M	62		12		87		93
Y	97		66		12		0
K	0		36		0		0

736

737

738

739

740

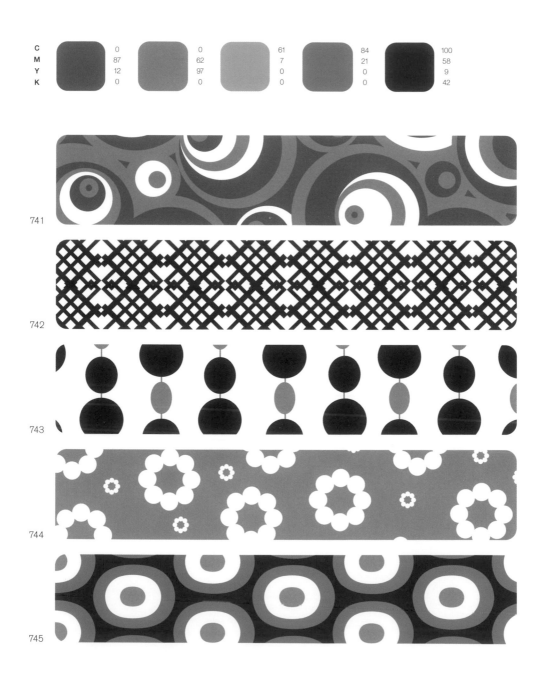

C	0		0		61		84		100
M	87		62		7		21		58
Y	12		97		0		0		9
K	0		0		0		0		42

741

742

743

744

745

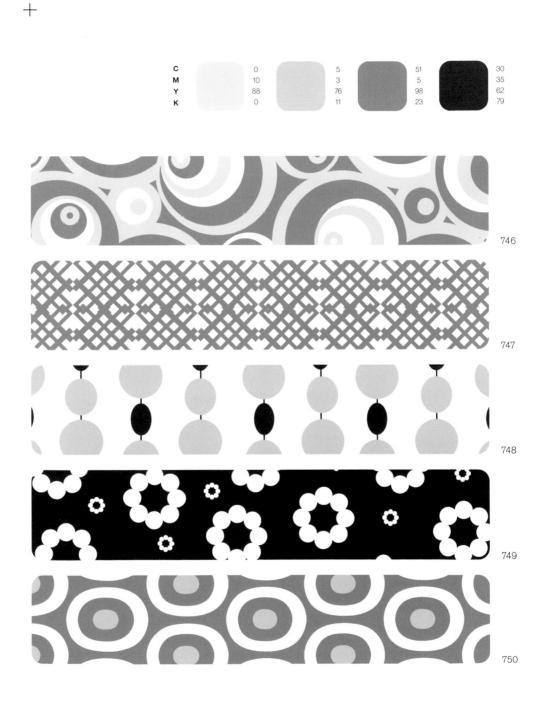

C	0	5	51	30
M	10	3	5	35
Y	88	76	98	62
K	0	11	23	79

746

747

748

749

750

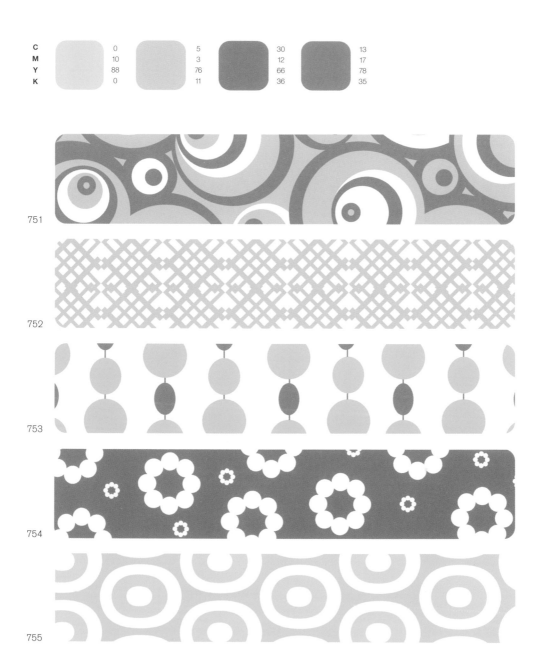

C	0	5	30	13
M	10	3	12	17
Y	88	76	66	78
K	0	11	36	35

751

752

753

754

755

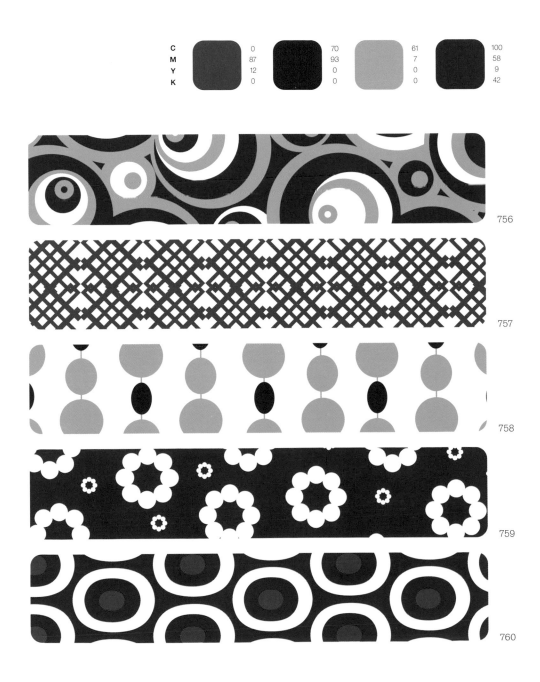

C	0	70	61	100
M	87	93	7	58
Y	12	0	0	9
K	0	0	0	42

756

757

758

759

760

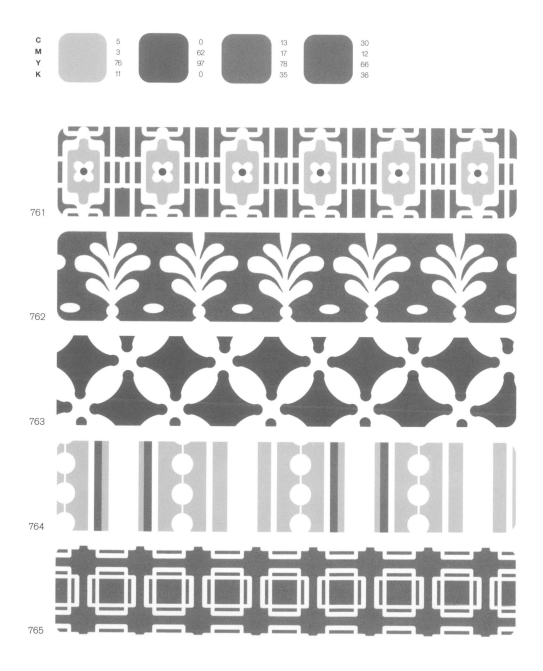

C	5		0		13		30
M	3		62		17		12
Y	76		97		78		66
K	11		0		35		36

761

762

763

764

765

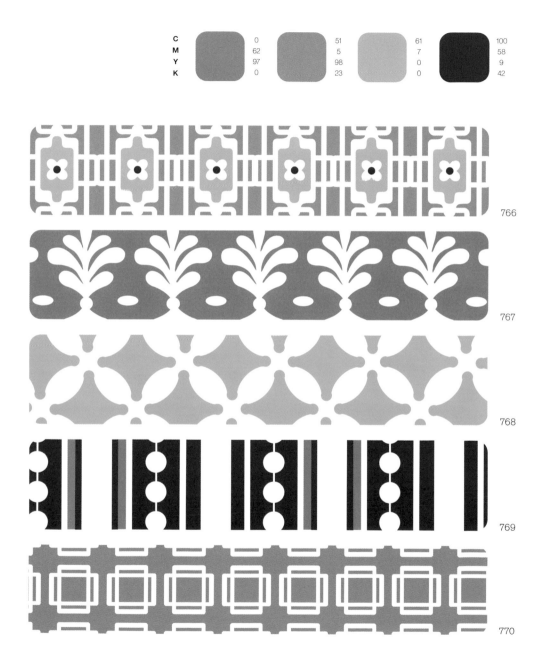

C 0 51 61 100
M 62 5 7 58
Y 97 98 0 9
K 0 23 0 42

766

767

768

769

770

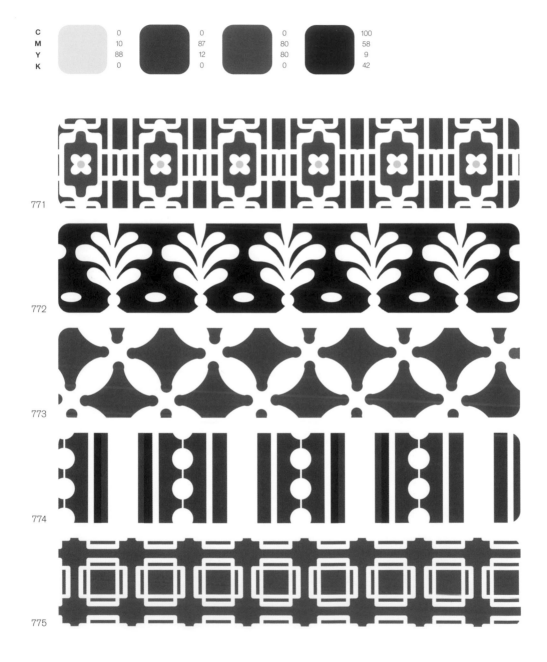

C	0	0	0	100
M	10	87	80	58
Y	88	12	80	9
K	0	0	0	42

771

772

773

774

775

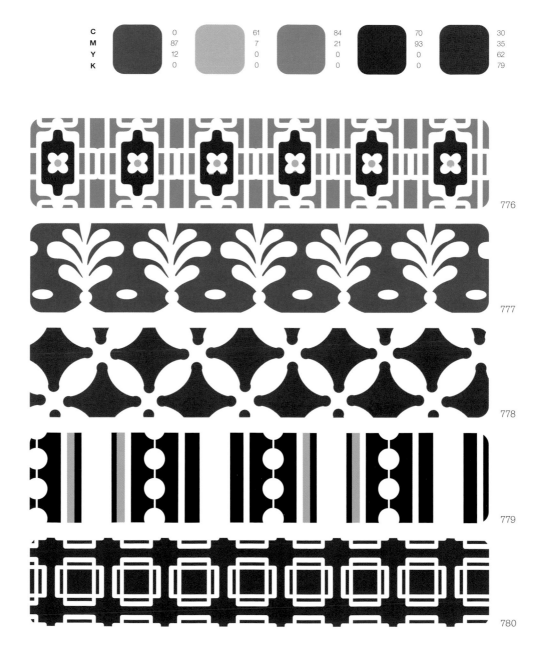

C	0		61		84		70		30
M	87		7		21		93		35
Y	12		0		0		0		62
K	0		0		0		0		79

776

777

778

779

780

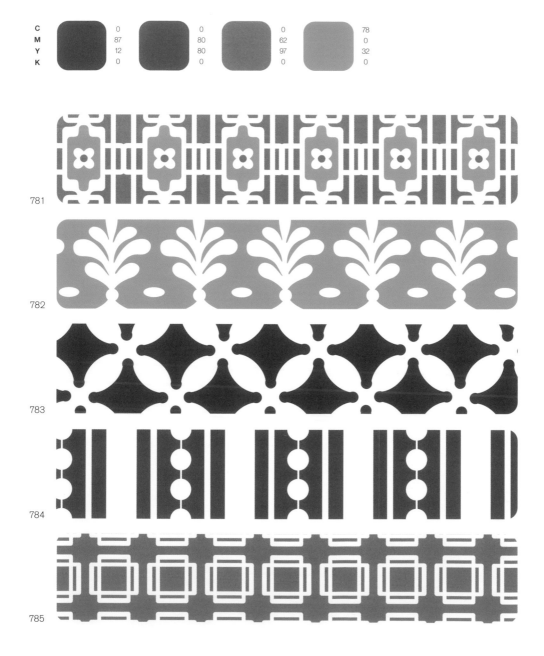

C	0	0	0	78
M	87	80	62	0
Y	12	80	97	32
K	0	0	0	0

781

782

783

784

785

C	5		84		78		30
M	3		21		0		12
Y	76		0		32		66
K	11		0		0		36

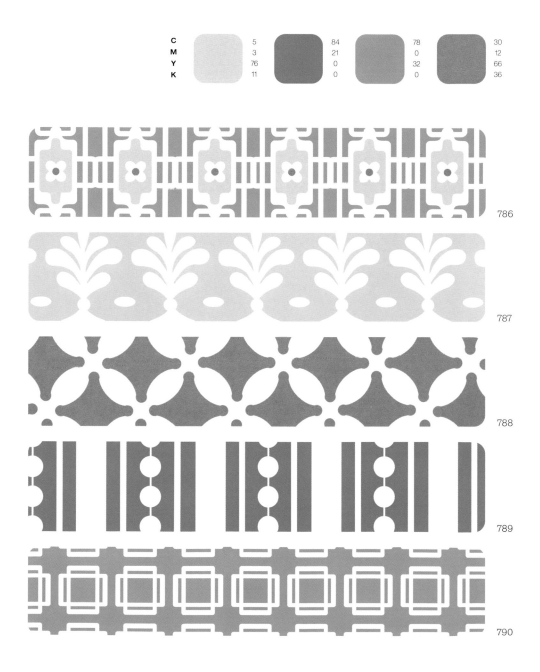

786

787

788

789

790

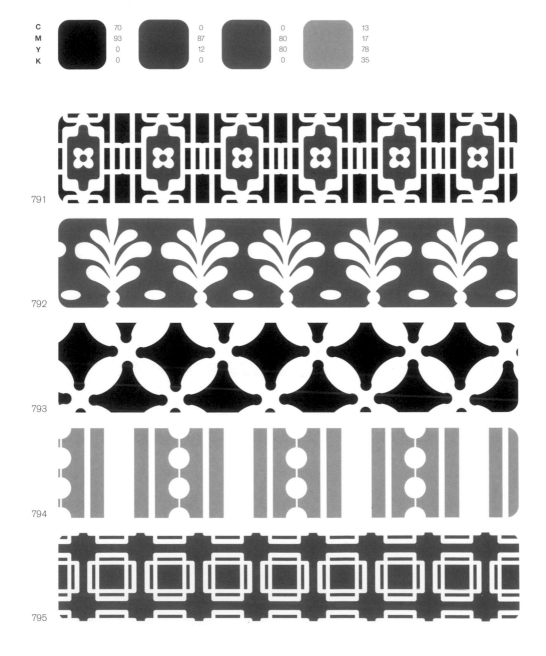

C	70	0	0	13
M	93	87	80	17
Y	0	12	80	78
K	0	0	0	35

791

792

793

794

795

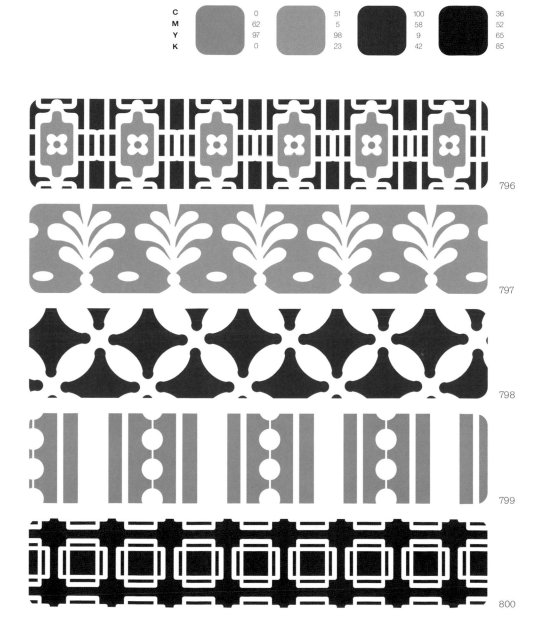

C	0		51		100		36
M	62		5		58		52
Y	97		98		9		65
K	0		23		42		85

796

797

798

799

800

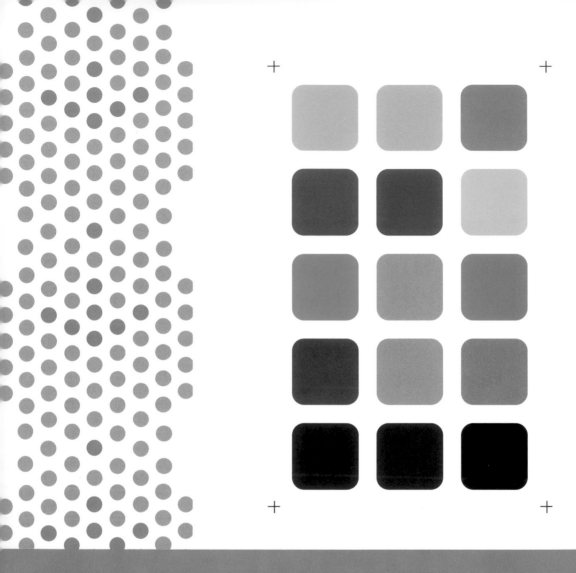

Art is found in everything, from nature to emotions; we love to focus on the beautiful things. This set of patterns, ironically, celebrates the gritty city and all things urban. It is rare to see such elements as light posts, asphalt, and wire recreated with such style. Explore the relationship of shapes to shades and enjoy how everyday living has been beautifully transformed into art within the pages of Urban Vivant.

Urban Vivant

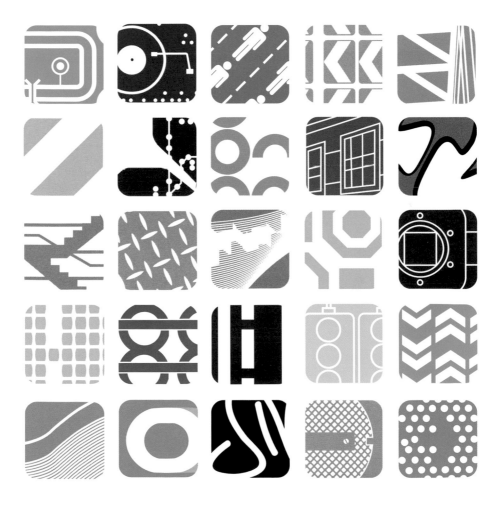

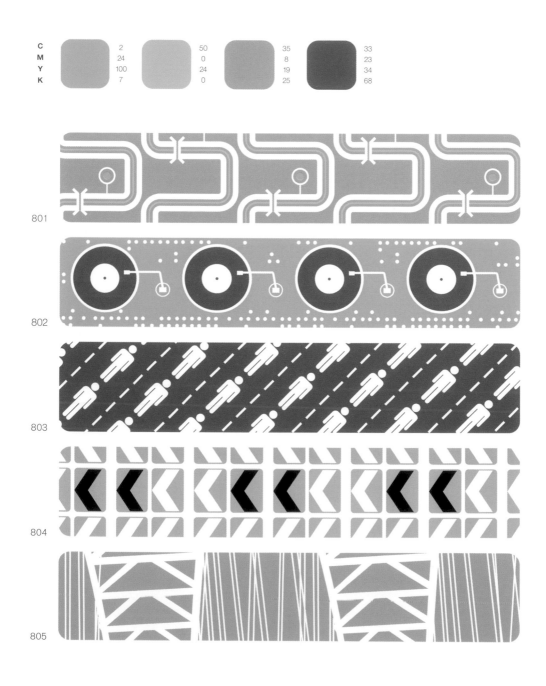

C				
C	2	50	35	33
M	24	0	8	23
Y	100	24	19	34
K	7	0	25	68

801

802

803

804

805

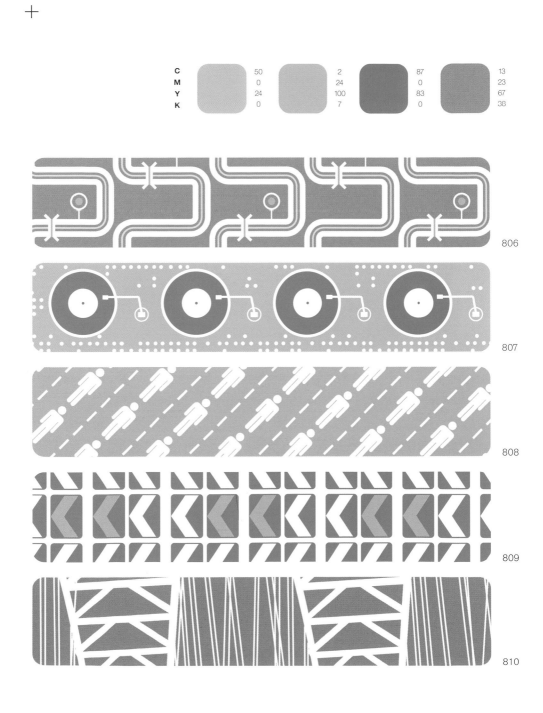

C	50		2		87		13
M	0		24		0		23
Y	24		100		83		67
K	0		7		0		38

806

807

808

809

810

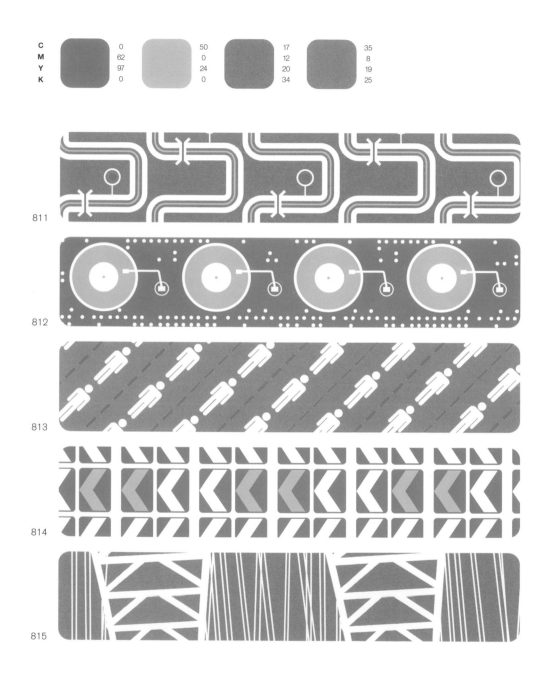

C	0		50		17		35
M	62		0		12		8
Y	97		24		20		19
K	0		0		34		25

811

812

813

814

815

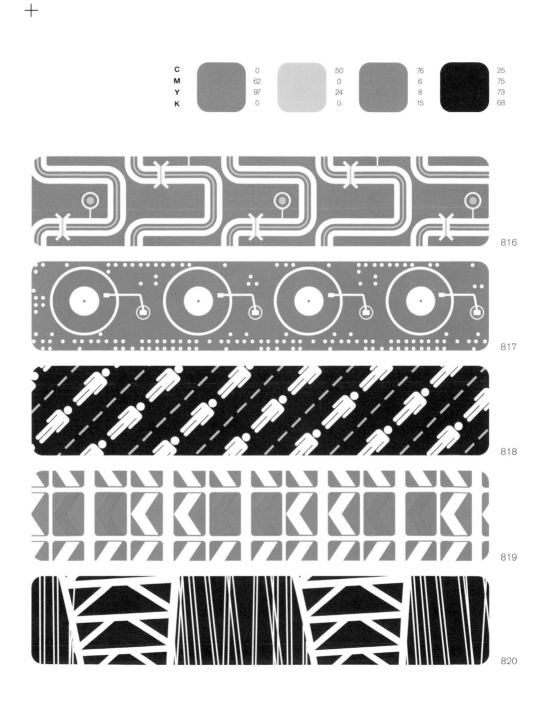

C	0		50		76		25
M	62		0		6		75
Y	97		24		8		73
K	0		0		15		68

816

817

818

819

820

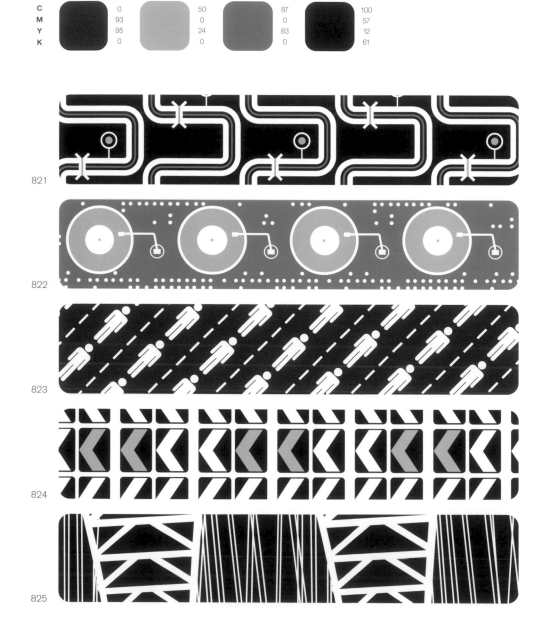

C	0	50	87	100
M	93	0	0	57
Y	95	24	83	12
K	0	0	0	61

821

822

823

824

825

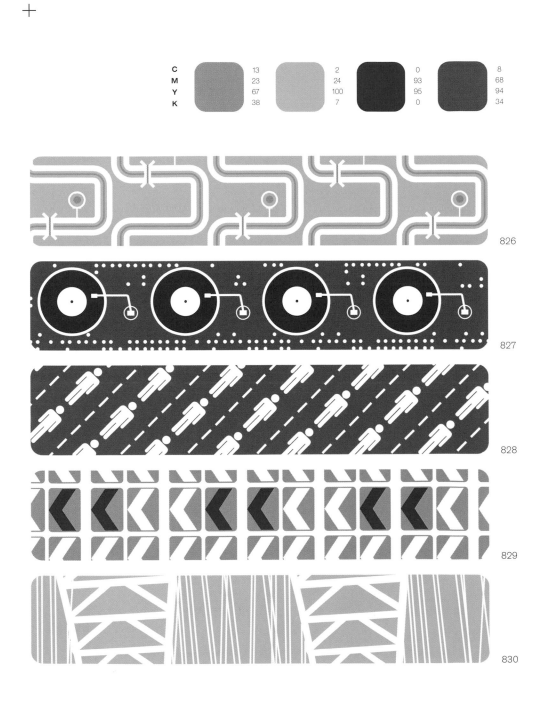

C	13		2		0		8
M	23		24		93		68
Y	67		100		95		94
K	38		7		0		34

826

827

828

829

830

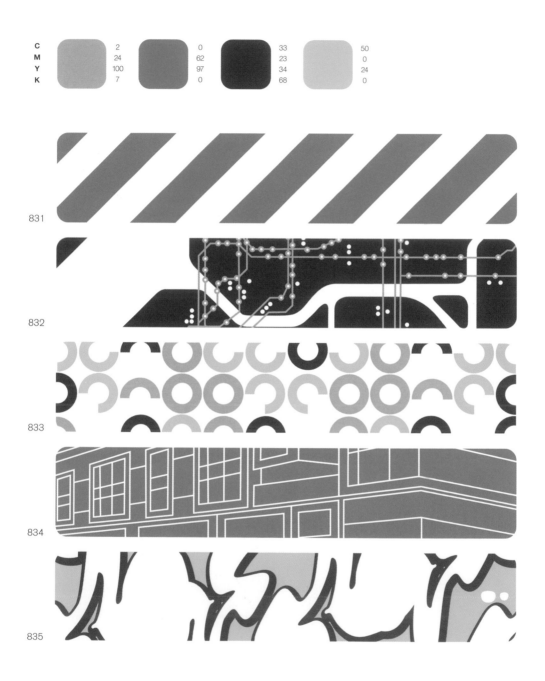

C	2		0		33		50
M	24		62		23		0
Y	100		97		34		24
K	7		0		68		0

831

832

833

834

835

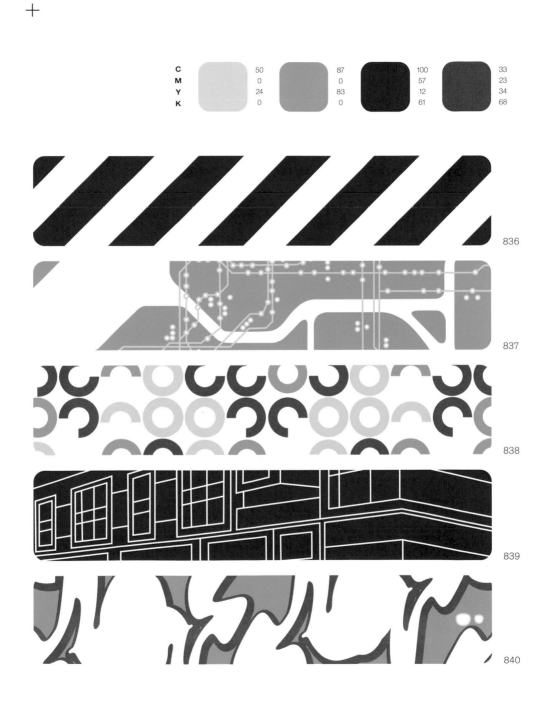

C	50		87		100		33
M	0		0		57		23
Y	24		83		12		34
K	0		0		61		68

836

837

838

839

840

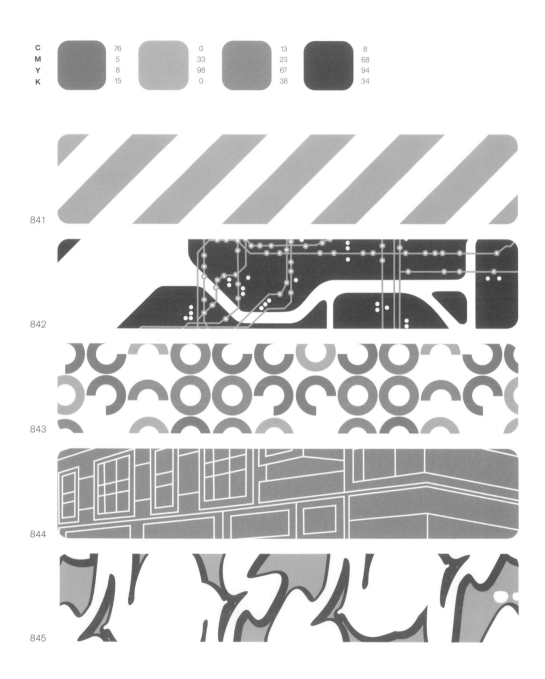

C 76 0 13 8
M 5 33 23 68
Y 8 98 67 94
K 15 0 38 34

841

842

843

844

845

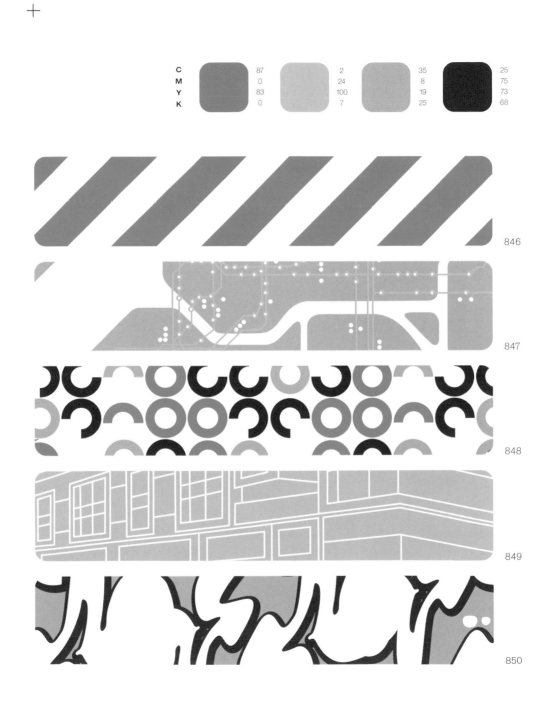

C	87	2	35	25
M	0	24	8	75
Y	83	100	19	73
K	0	7	25	68

846

847

848

849

850

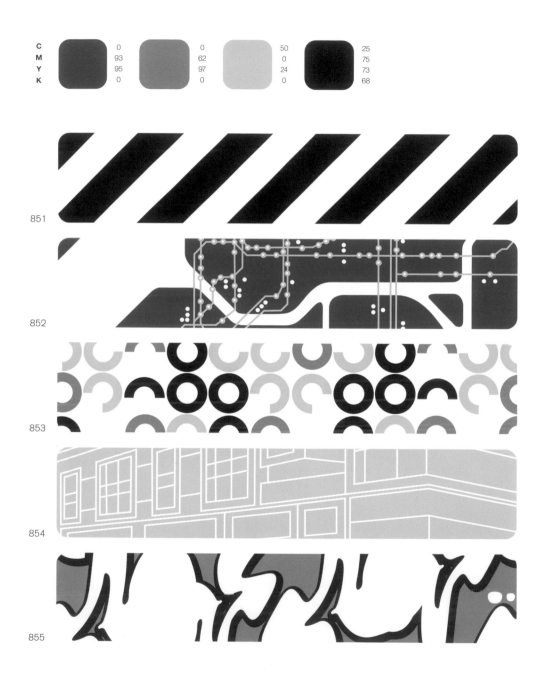

C	0		0		50		25
M	93		62		0		75
Y	95		97		24		73
K	0		0		0		68

851

852

853

854

855

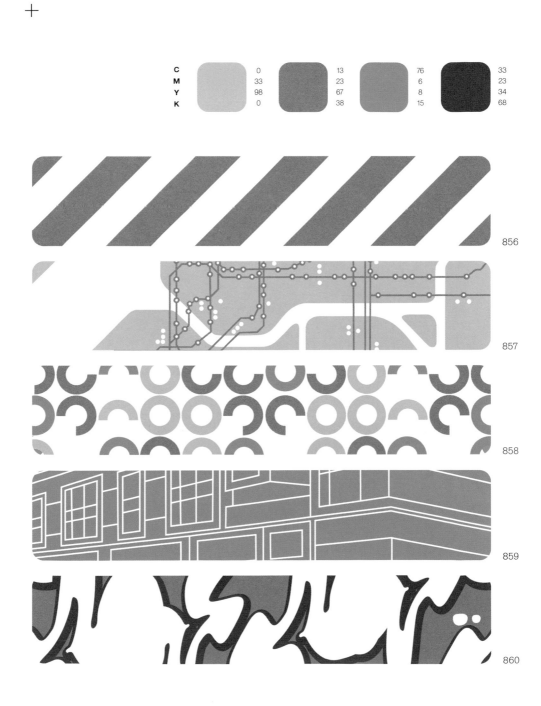

C	0	13	76	33
M	33	23	6	23
Y	98	67	8	34
K	0	38	15	68

856

857

858

859

860

Urban Vivant 189

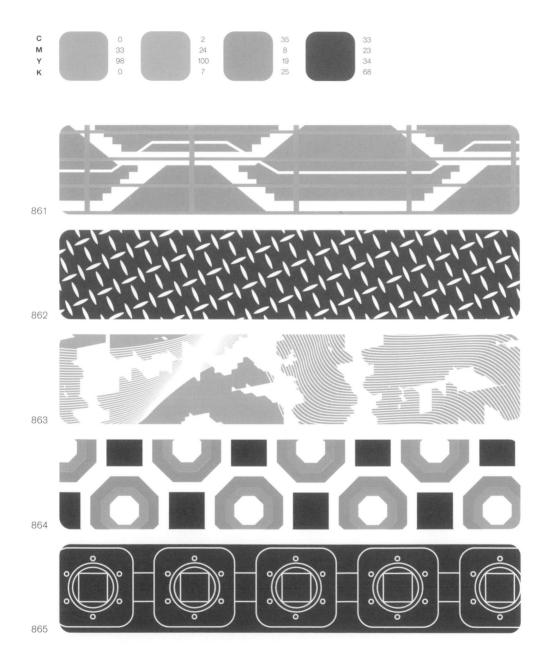

| | | | | | | | | |
|---|---|---|---|---|---|---|---|
| C | 0 | | 2 | | 35 | | 33 |
| M | 33 | | 24 | | 8 | | 23 |
| Y | 98 | | 100 | | 19 | | 34 |
| K | 0 | | 7 | | 25 | | 68 |

861

862

863

864

865

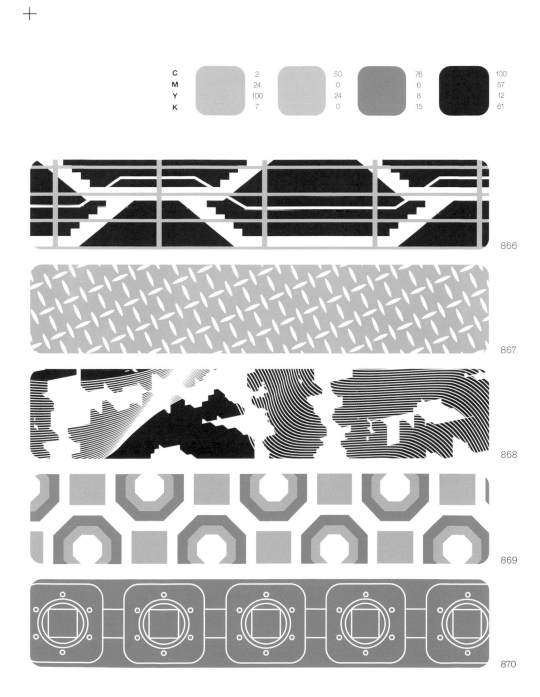

C	2		50		76		100
M	24		0		6		57
Y	100		24		8		12
K	7		0		15		61

866

867

868

869

870

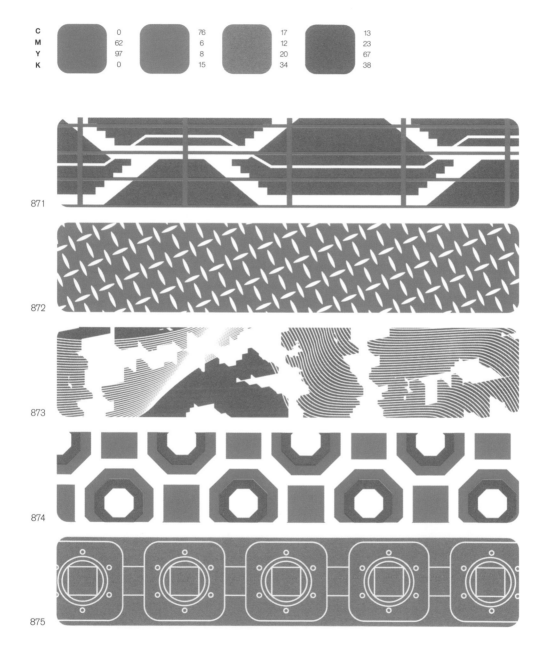

C	0		76		17		13
M	62		6		12		23
Y	97		8		20		67
K	0		15		34		38

871

872

873

874

875

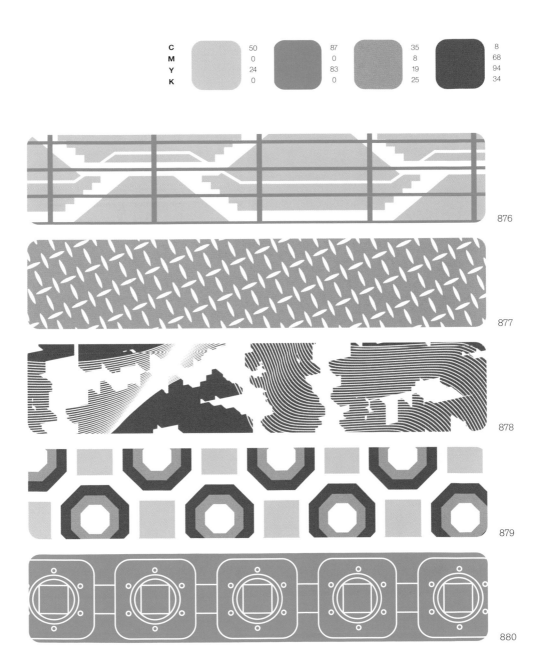

| | | | | | | | | |
|---|---|---|---|---|---|---|---|
| C | 50 | 87 | 35 | 8 |
| M | 0 | 0 | 8 | 68 |
| Y | 24 | 83 | 19 | 94 |
| K | 0 | 0 | 25 | 34 |

876

877

878

879

880

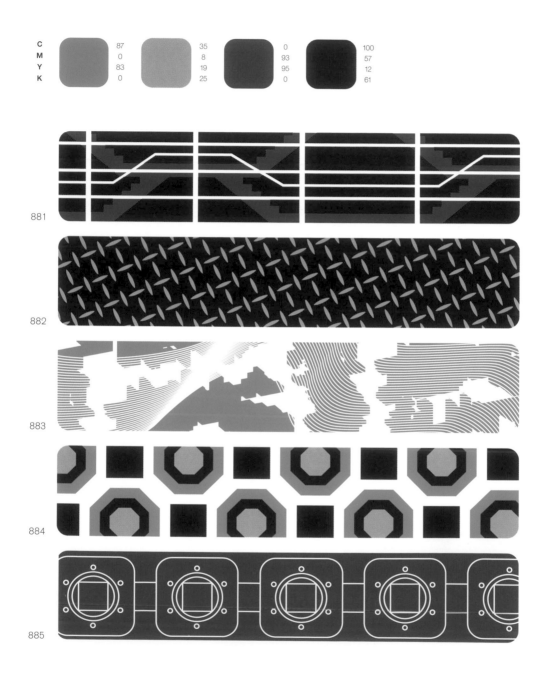

C	87		35		0		100
M	0		8		93		57
Y	83		19		95		12
K	0		25		0		61

881

882

883

884

885

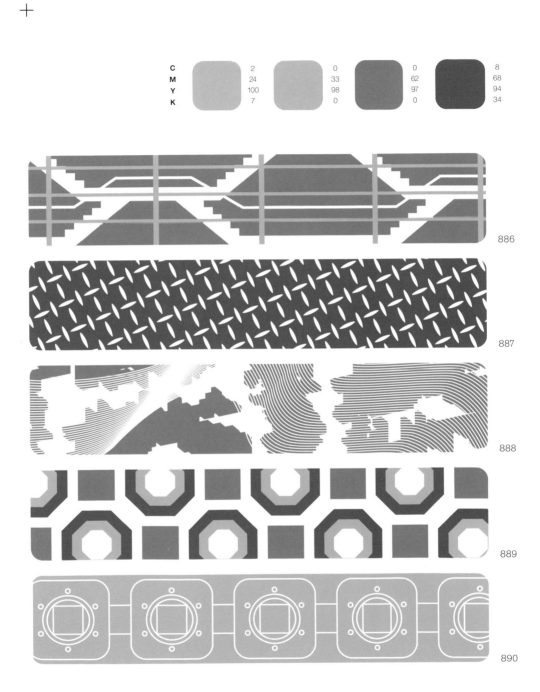

C	2		0		0		8
M	24		33		62		68
Y	100		98		97		94
K	7		0		0		34

886

887

888

889

890

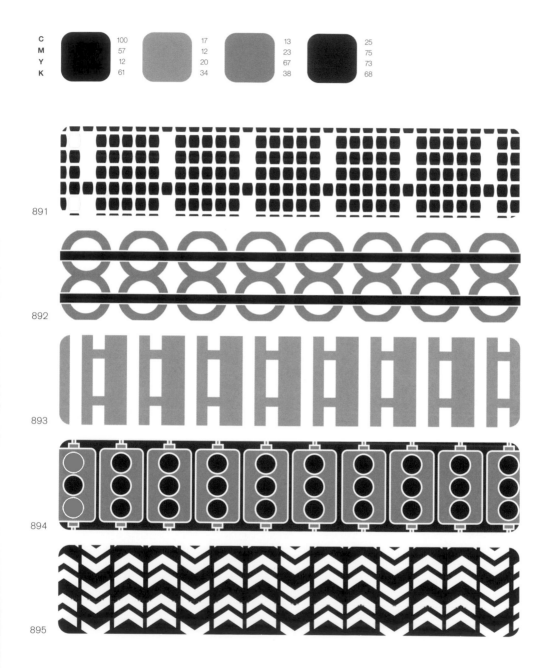

C	100		17		13		25
M	57		12		23		75
Y	12		20		67		73
K	61		34		38		68

891

892

893

894

895

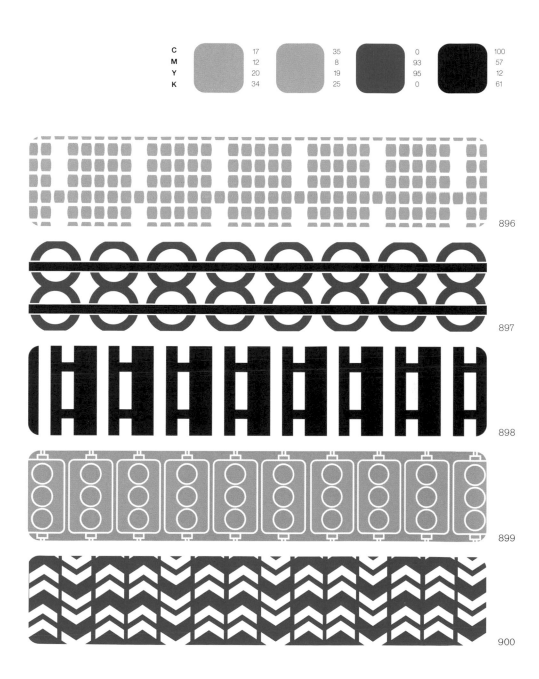

C	17		35		0		100
M	12		8		93		57
Y	20		19		95		12
K	34		25		0		61

896

897

898

899

900

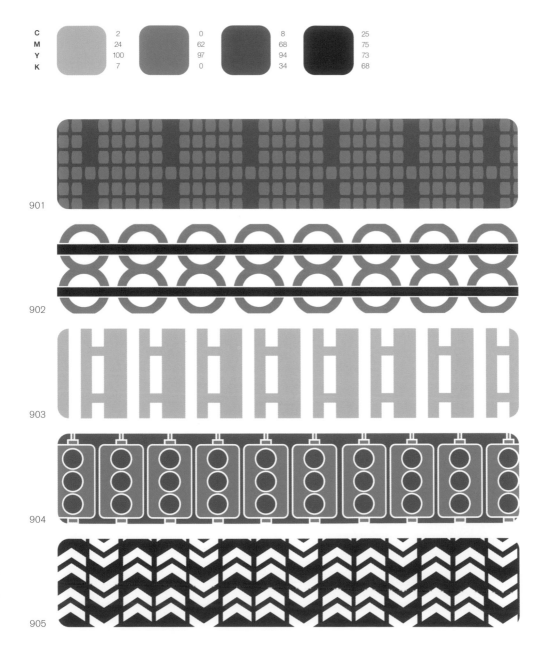

C	2		0		8		25
M	24		62		68		75
Y	100		97		94		73
K	7		0		34		68

901

902

903

904

905

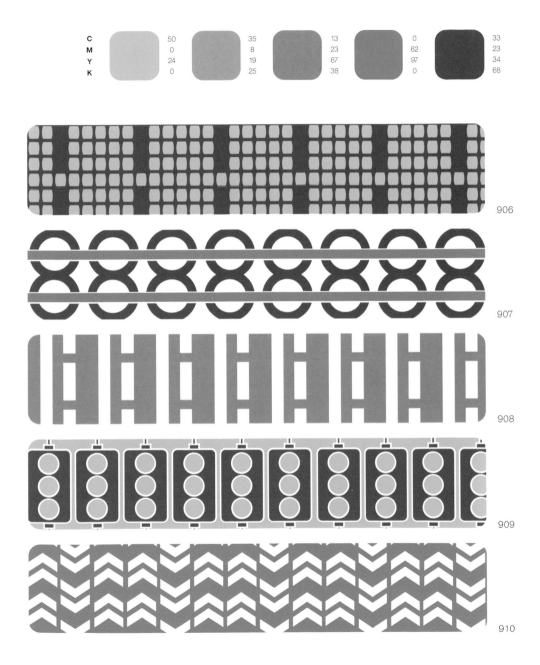

C	50	35	13	0	33
M	0	8	23	62	23
Y	24	19	67	97	34
K	0	25	38	0	68

906

907

908

909

910

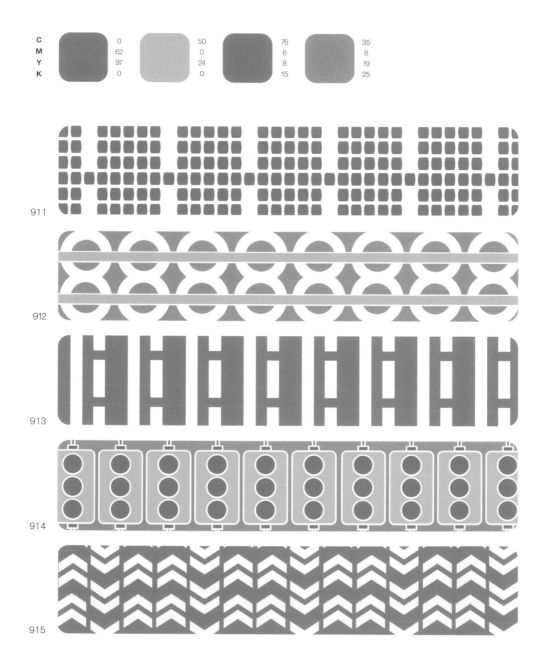

C	0	50	76	35
M	62	0	6	8
Y	97	24	8	19
K	0	0	15	25

911

912

913

914

915

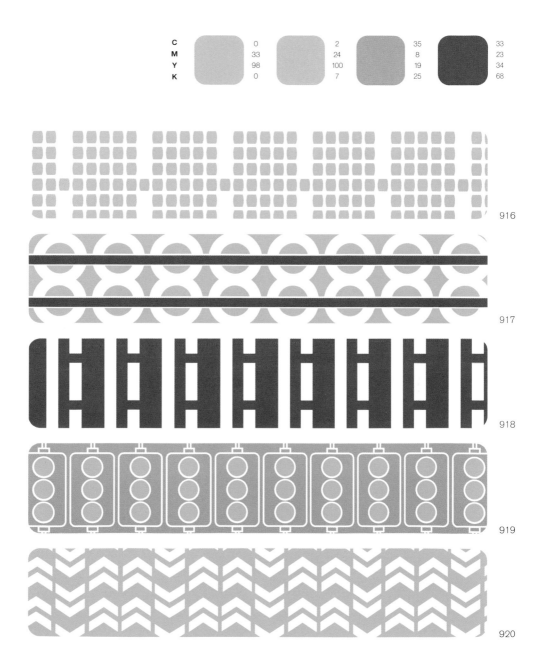

C	0		2		35		33
M	33		24		8		23
Y	98		100		19		34
K	0		7		25		68

916

917

918

919

920

C	2		87		50		100				
M	24		0		0		57				
Y	100		83		24		12				
K	7		0		0		61				

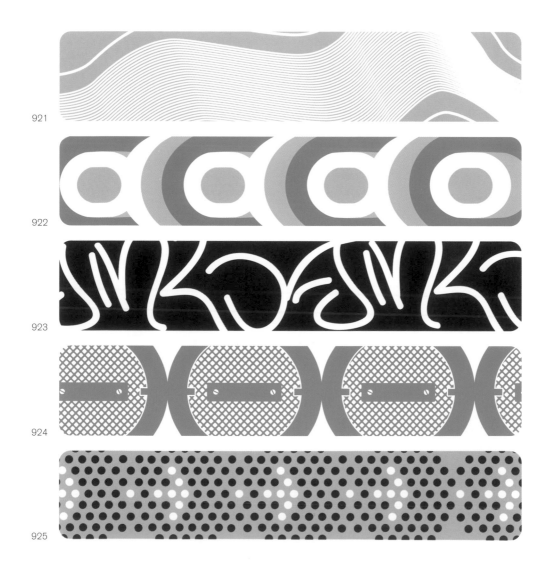

921

922

923

924

925

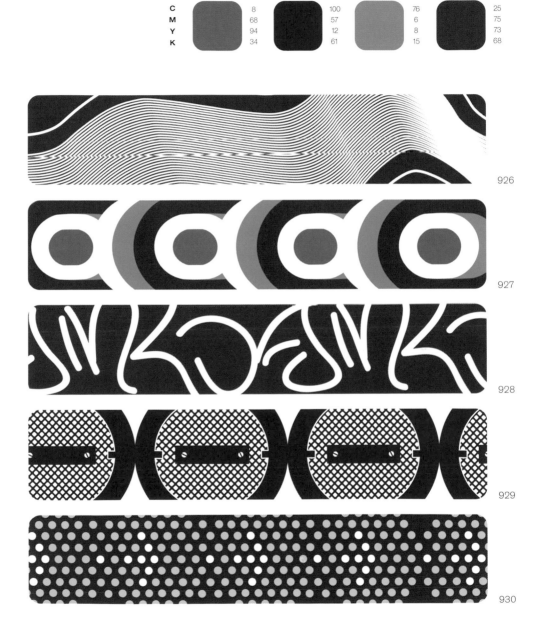

C	8		100		76		25
M	68		57		6		75
Y	94		12		8		73
K	34		61		15		68

926

927

928

929

930

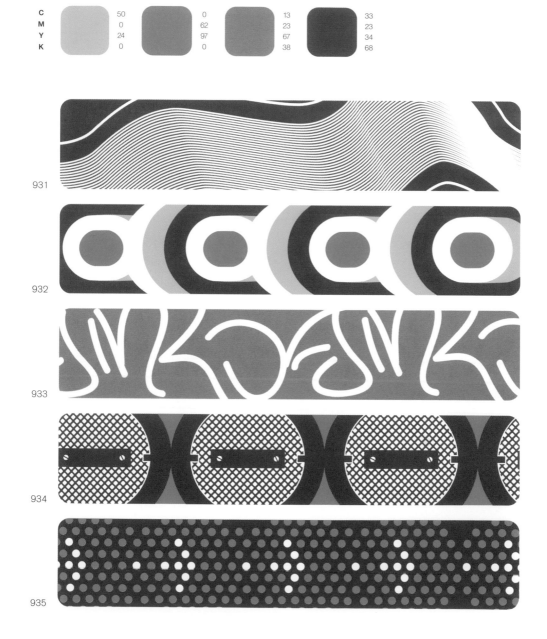

C	50		0		13		33
M	0		62		23		23
Y	24		97		67		34
K	0		0		38		68

931

932

933

934

935

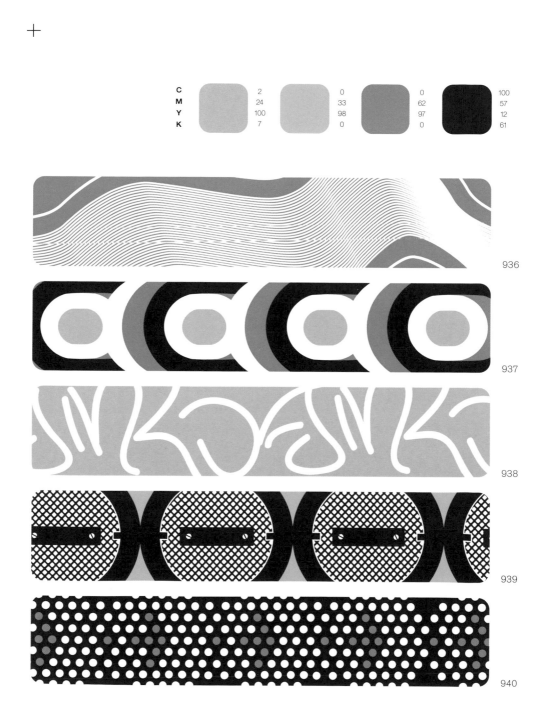

C		2		0		0		100
M		24		33		62		57
Y		100		98		97		12
K		7		0		0		61

936

937

938

939

940

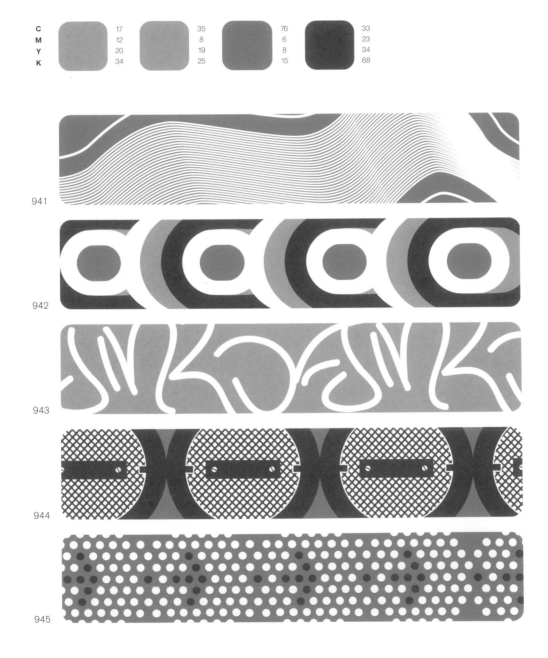

C	17	35	76	33
M	12	8	6	23
Y	20	19	8	34
K	34	25	15	68

941

942

943

944

945

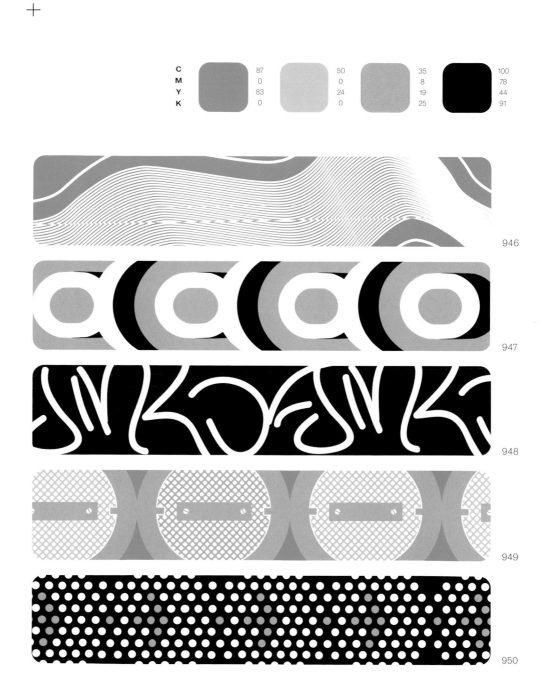

C	87		50		35		100
M	0		0		8		78
Y	83		24		19		44
K	0		0		25		91

946

947

948

949

950

About the Author

Photo: Mona Brooks

After searching for the ideal gift-wrap solutions that captured her joie de vivre and love of fashion, **Heidi Arrizabalaga** stopped looking and focused on creating.Heidi took her decade's worth of product development and graphic design expertise and focused on crafting a paperie line, HEIDI, that complemented her sophisticated style. Incorporating her keen understanding of color, texture, and glamour, she developed a thoughtful, versatile collection of vibrant, coordinating paper journals, note sets, gift-wrap collections, and accessories. HEIDI is in 40 stores across the country and can also be found at www.shopheidi.com. HEIDI has been featured in *InStyle* Magazine, *Lucky*, Daily Candy, *Martha Stewart Living*, and many other outlets. Her philosophy is one of invention and experimentation. Heidi's incessant curiosity about the interplay of form and function motivated her to enter the world of patterns and home décor. With her HEIDI line growing, she is now consulting with clients who seek her expertise in textile design and home décor.